# ARMANI ANGELS

# CUTTING IT

## Jasmine Oliver

**SIMON AND SCHUSTER**

**SIMON AND SCHUSTER**

First published in Great Britain by Simon & Schuster UK Ltd, 2005

A Viacom company

1 3 5 7 9 10 8 6 4 2

Simon & Schuster UK Ltd

Africa House

64-78 Kingsway

London WC2B 6AH

A CIP catalogue record for this book is available from the British Library

ISBN 1 416 90105 1

Typeset by M Rules

Printed and bound in Great Britain by

Cox & Wyman Ltd, Reading, Berkshire

# ONE

'Frankie McLerran, where are your goggles?'

'Whoa!' Frankie jumped and dropped a blob of molten silver into a glass dish containing a dozen tiny gemstones.

'Always wear goggles in the workshop,' barked Claudia Brown in her scary, sergeant-major voice, 'unless you want to lose an eye!'

Frankie scraped up the precious metal and returned it to its tiny crucible. She turned up the flame, jammed a pair of goggles over her eyes and started again.

'Leopard print is *so* last year!' Tristan Fox told Marina with an airy wave of his hand. 'Think rope-thong sandals, or combine canvas with snakeskin. Try something adventurous!'

Marina studied her shoe design – leopard print sandals with silver three-inch heels and a slight platform sole.

Tristan never praised her, or anyone's work, on principle.

'"Leopard print is *so* last year!"' she mimicked in a high voice behind the lecturer's back.

'I heard that!' Tristan warned, walking away without turning his head.

'Oops!' Anyhow, Marina had to admit that Tristan did know what he was talking about. After all, he designed for Charles Jourdan. He *was* Mister Chaussure UK!

So she scrapped her big-cat platforms and began on a gold leather idea instead.

*Pirates!* Sinead thought. That *can be my theme!*

Not pirates, as in Peter Pan, but pirates, as in billowing shirts of the flimsiest see-through fabric, sexy low-slung wide leather belts, cut-off white pants and saggy tan leather boots. The shirt would be laced down the front to show plenty of flesh, and maybe she should do away with the trousers and just have long, tanned

legs meeting the mid-calf boots instead . . . Oh, and the widest of wide-brimmed, white, tricorn hats.

She worked on her summer design in the top-floor cutting room, surrounded by stripes and zigzags, beads, buttons and badges. There wasn't another soul around, just a track from her latest CD playing, until Marina burst in on her paradise with, 'Hey, Sinead, look out of the window – it's snowing!'

'It's snowing!'

Sinead and Marina rushed down to the college basement to drag Frankie out of the jewellery workshop.

'Back off . . . critical moment . . . can't stop!'

'But it's snowing!' Marina insisted. 'Real snow. Flakes as big as – *this*!'

All around, jewellery-making machines whirred, ground, polished and pounded. Frankie took off her goggles and looked up. 'Where's Claudia?'

'Taking a break. We just saw her going into the staff coffee bar,' Sinead told her.

'Come *on*, Frankie, before the snow stops!'

'Hey, you realise you broke my concentration!' Frankie sighed, exasperated.

'Sorry. We didn't see the "Genius at Work" sign.' Stretching the elastic on Frankie's goggles, Marina let it snap back into place.

'Ouch!' Frankie yelped. 'OK, you win!'

'Look at that!' Sinead had her cold hands wrapped around a cup of coffee from the machine in the entrance hall. People were coming in covered in a white crust, shaking flakes out of their hair, brushing them off their jackets, stamping their feet. 'There must be a fall of two or three inches out there.'

'I couldn't see anything down in the windowless dungeon,' Frankie said. 'But hey, this is snow-tastic!'

'Snow-tastic?' Sinead echoed.

'Ignore her,' Marina muttered. 'The girl has her own private language. But, oh, what a shame . . . it looks like I won't be able to get to work tonight!' She smirked at the prospect – until Frankie burst her bubble.

'Unless it thaws . . .' she chipped in.

'Thanks for that. Like, I really want to go to

work in a scuzzy pub!' Marina ventured to the door and poked her nose outside.

'Frickin' freezing!' she reported back. Then, 'We could build a snowman!'

'Or have another coffee,' Sinead suggested hastily. She would far rather *look* at the snow than be out in it. The transition from flimsy pirate shirts to icy snowmen was one step too far.

'Wuss!' Frankie declared, running for the door and bundling Marina outside.

Sinead sighed loudly and followed.

Dressed in jeans, sweaters and scarves, the three girls plunged across the college yard, kicking up the snow and stooping to scoop it into a small hillock that would form the base of their snowman's body.

'No gloves!' Sinead shivered, her hands already numb.

'Make him taller!' Frankie insisted. She had snowflakes in her long black hair and chunks of ice clinging to her stripey jumper.

'I'll make his head.' Quickly Marina knelt down and rolled a giant ball. 'Here, stick this on top!'

'Wicked! I haven't made a snowman since I was—' Sinead began. *Whack!* A snowball hit her square on the back of the head.

'Hey!' Marina cried, as a second snowball whizzed by, a millimetre from her face.

Frankie swung round with a fistful of snow. She packed it tight into a ball and flung it across the yard at Marina's boyfriend, Rob, and Sinead's Travis. Soon a full-scale fight was underway.

'Bull's-eye!' Rob laughed, scoring a maximum hit against Marina's chest.

'I'm so over you, Rob Evans!' she yelped, charging at him with an armful of snow. She collided with Rob and they both rolled to the ground.

'Hey, not two against one!' Travis yelled, as Sinead and Frankie attacked him.

The girls pelted him, backing him into their snowman, which collapsed in an unrecognisable heap.

'Now look what you did to our masterpiece!' Sinead laughed, falling into his arms.

Breathless, Frankie stood for a moment to brush herself down. Snowflakes floated down

like feathers, the cold making her cheeks tingle. By now, other people were out in the yard doing the snowfight thing – the whole place was alive with kids sliding and skidding around, chucking snowballs and wrestling in the snow.

Then, 'Whoa!' For Frankie, one figure stood out from all the rest.

A guy she'd never seen before had made a pile of ammunition and placed it on the low wall surrounding the mosaic and steel fountain designed way back in the sixties by some famous abstract sculptor. He was a tall guy, dressed in a short, bomber-style brown leather jacket with sheepskin collar and straps everywhere, and jeans that made his legs go on for ever. The stranger's snowballs were neat and regular. He took up three of them one by one and started to juggle them in the air.

Frankie sighed, mesmerised by the sight.

The balls went up in a perfect arch, and the guy caught them and threw again. He stood, legs slightly bent, never taking his eyes off the three balls.

'Impressive!' Frankie didn't take *her* eyes off

the juggler guy until Marina and Sinead finally came and dragged her inside to the coffee bar.

'I'll kill that Rob!' Marina said, delving down the front of her sweater and prising compacted, half-melted snow from the front of her bra. 'Yuck!'

'Travis is so not getting me to go to his place for Christmas after this!' Sinead swore, only half joking. Her hands were blue with cold.

'Listen, I've just seen this amazing guy and I've no idea who he is!' Frankie told them. 'He's tall, with short fair hair and cheekbones that come high like this . . . and a really cool bomber jacket . . . oh, and he juggled!'

'No way!' Sinead told Travis later that evening.

Snow lay in a white blanket over Walgrave Square. She and Marina were at Rob and Travis's place. Marina was cooking spaghetti with tomato and basil sauce.

'I mean, imagine how Daniella would feel if I didn't go home to Dublin for Christmas.'

Travis bit his thumbnail and stared at the TV. 'Yeah well, think of my folks. Christmas is a big

deal for them, too. They're expecting me. In fact, they've already ordered the turkey.'

Sinead wrinkled her nose. 'Daniella's booked a table at her favourite restaurant. She takes me there for Christmas dinner every year.'

'Would it kill your mother if she had to un-book it?'

'She'd be by herself, idiot.'

'Hey, break it up, you two,' Rob cut in, turning up the volume on the TV. 'It's snooker – the semi-final, OK?'

Marina came and put three dishes down on the coffee table. 'Spaghetti, anyone?'

'Mmm, cool.'

'*Muchos gracias!*'

'Not for me, thanks.'

Rob and Travis dug in, while Sinead stared fixedly at shiny red balls shooting across green baize into corner pockets.

Marina sat down next to Rob in her micro mini and crossed her long legs. 'Did I tell you, Frankie's in lust?'

'Who with?' Rob asked.

On the screen, a snooker player with a thin ponytail rubbed chalk on the end of his cue.

'Dunno. Some juggler guy.'

The player crouched over the table, aimed and fired.

'Tall?'

'Yeah.'

'Fair hair?'

'Yep.'

*Click!* The ball shot into the pocket.

'Dutch?'

'Dunno. Maybe.' Marina grabbed the remote. She turned down the sound. 'Rob, are you telling me you know him?'

'Dunno. Maybe. Did you see the way he ricocheted the red ball off the cushion into the blue?'

'Rob!'

'Yeah. There's a Dutch guy called Wim who's staying at Lee Wright's place. I heard he does juggling and stuff.'

'Uh-oh, not good!' Marina groaned. Lee was a mate of Rob's, a second-year moving-images student with a long-term crush on Frankie. Frankie called him Velcro Boy. If this Wim-Wam-Bam was staying with Lee, that definitely complicated things.

'Wait here,' she told the others, putting down her spaghetti fork and heading for the door. 'I need to go across the square and have a little chat with our Frankie!'

A garland of seed pearls, a deep choker of plain, burnished silver, a string of yellow angel fish carved out of wood, alternating with big red stars, hanging down to the waist ... ideas flowed from Frankie's head onto the page. She saw the necklaces in her imagination as clearly as if they lay on the bed beside her – big, bold, ethnic designs.

This was the one advantage of not having a boyfriend, she thought. Relationships took up too much time – time which could be used working on her designs instead. Take Marina and Sinead, for instance. There they were now, most likely flaked out in front of the telly over at Rob's place, or down the pub drinking.

Frankie sketched a swathe of raw-edged, plum coloured silk, woven in amongst the same shade of sequins and beads – half scarf, half necklace. Then she paused. *An image of a tall guy, with fair hair, throwing snowballs in clean arcs*

*over his head flashed into her mind. Really, really tall, probably six-four or five . . .*

She frowned. How did she let that memory stray into her head?

She shook her head to dislodge it. Now . . . A necklace made of fake fur and leather. How would that work?

*Probably not English. His clothes didn't look English. That jacket was cool . . . Stay out of my head, you juggler!*

The front door opened and Marina burst in.

'Frankie!' she yelled.

'I'm up here!'

'In your room? Listen, babe, I just heard something from Rob about that juggler guy.'

'I'm working!' Frankie protested as Marina barged through the door and sat on top of her sketches on the bed.

'No, listen! The juggler's Dutch. His name's Bim – Vim – Wim – something that sounds like a detergent . . .'

Frankie put down her pencil. 'Tell me more,' she said.

'That's it. That's all the gossip.'

'No, it isn't. You wouldn't have rushed back

just to tell me that.' After nearly a whole term as housemates, Frankie could read Marina as clearly as one of the blogs she insisted on sending out into the ether.

'His name's Wim. He's Dutch.'

'And?'

'OK, he's staying at Lee Wright's place on Nugent Road.'

'Aieeee!' Frankie cried in mock horror.

Then the front door opened again and Sinead came flying up the stairs.

'That's it!' Sinead cried, dashing headlong across the landing, past Frankie's room.

'What's "it"?' Marina and Frankie exchanged glances. Marina got up and followed Sinead into the bathroom.

Sinead flung down the loo seat and sat down in floods of tears. 'I've had it with Travis!' she sobbed. 'He's so up himself. He always wants things his own way!'

'Yeah, so what's new?' Marina drawled. 'Babe, didn't you read the dictionary definition? Man equals Ego, the big "I Am"!'

Frankie came quietly along the landing and stood in the doorway. 'Hey, Sinead, don't cry.'

Sinead sat with her head forward, her soft, short blonde hair falling across her face. 'I just chucked him,' she confessed.

'You chucked Travis?' Marina and Frankie echoed.

'I told him I didn't want to see him any more,' Sinead confirmed, leaning forward and crying as if her heart would break.

# TWO

Music blasted through the house; make-up lay scattered over every surface.

'I'm into prints,' Frankie declared. 'The bigger and bolder the better – da-dah!' She paraded the landing as if it was a catwalk, leaning back and slinking her hips.

'Wowee!' Marina whistled. 'Very sixties.'

'With my knee-length white boots?' Frankie checked, smoothing the wrinkles out of the orange, brown and white pop-art dress. 'Or my brown lacy tights and platforms?'

'Boots, with this orange feather boa!' Sinead told her. 'Here, borrow this.' For herself she'd opted for sequins – a deep-red shirt cinched at the waist, with peter-pan collar and frog-fasteners. Sequins shimmered in narrow stripes

15

down her floaty skirt, like a waterfall of glitter on the crimson background. She would wear her red suede Christian Louboutin ankle boots – Daniella's cast-offs, of course, but still shoes to die for!

'Is this eyeshadow too OTT?' Marina asked, emerging from the bathroom in a black bustier and short frilled skirt.

'The eyes are fine, babe, but lose the stockings and suspenders,' Frankie suggested. 'You'll get arrested if you go out like that.'

'Party pooper!' Marina grumbled. 'You sound like Rob.'

'Yeah well, it's too much. You're a respectable, coupled-up girl!'

'And this is a girls' night, to celebrate Sinead's new-found freedom,' Marina argued, but she lost the stockings anyway, and went for the tightest jeans in her wardrobe instead, teamed with four-inch heels and dangly bling earrings. 'Ready?' the Armani angel asked.

'Ready!' said the shimmering crimson showstopper.

'Ready!' echoed the Biba babe.

\*

The Salon was a new club in town. Purple was the colour theme – faded Parisian chic, with cracked gilt mirrors, silk drapes and frayed chaises-longues.

'Not too many students here, then,' Frankie said, sipping a cocktail through a straw.

'There's hardly anyone we know.'

They'd been in the club for ten minutes, checked out the dance floor and the DJ, visited the purple cloakroom and chatted up the barman.

'There's hardly anyone, period!' Frankie complained, gazing round the half-empty room. Maybe The Salon had been a mistake.

'At least we won't bump into you-know-who!' Sinead sighed, lining up her third cocktail.

'Yeah, do we know what the boys are doing tonight?' Marina stirred her drink and pouted at the rugger-playing Kiwi behind the bar.

'Travis said they were going to watch a new band,' Frankie reported. 'Sorry,' she mumbled, as Sinead winced at the sound of her ex's name.

Sinead shrugged. She caught the eye of a nearby group of guys, picked one out and smiled at him. 'No problem,' she told Frankie.

Sinead's eye contact brought the boy running. 'Dance?' he asked.

She nodded, stood up and shimmered. 'I'm so over Travis!' she told Frankie and Marina as she sashayed onto the dance floor.

Marina and Frankie stared at each other over their cocktails. 'She's so *not* over him!' they said.

'Bring your camera,' Rob suggested, putting on his bike helmet and zipping up his leather jacket. He'd had to drag Travis out of his room and prime him with a couple of cans of beer to get him this far.

'Man, do I have to?' Travis felt drained and stale. He was suffering from serious stubble and a mouth that felt like the inside of a camel's arse. Since splitting up with Sinead the night before he hadn't eaten or slept.

'Camera,' Rob ordered, shoving a second helmet against Travis's chest. 'Listen, this new band is cool. We need to check them out.'

'*Why* do we need to?' Travis moaned, reluctant.

'So we're ahead of the crowd. So I can play the best tracks from their new album before

every other DJ on the planet jumps on the bandwagon.' Rob took his moonlighting career seriously. Pretty soon he hoped it would allow him to chuck his day job as a technician at Central Fashion College.

'I'm doing this for you,' Travis grunted, snatching his camera bag from the shelf under the TV. 'I wouldn't do it for anyone else.'

Rob put on his helmet. 'Lighten up,' he told Travis in a muffled voice, getting as close as a guy like him ever did to discussing personal stuff. 'All you need to do is chill for a few days. She'll soon come running back.'

Travis doubted it. He stood on the front doorstep, looking across the square at Number 13. Christmas lights twinkled in the bare beech trees. Sinead's bedroom light was switched off.

Rob turned the bike ignition and opened the throttle. The engine roared. 'You coming?' he yelled.

Travis nodded. What else could he do – stay home and mope? 'What's this new band called?' he shouted over the *vroom-vroom* of Rob's bike.

'Bad Mouth.'

'Cool name,' Travis acknowledged, sitting pillion, before Rob put the Yamaha into gear and roared out of Walgrave Square.

*'You're the one that I want!'* John Travolta trilled. *'Ooh-hoo-hoo!'*

Sinead, Frankie and Marina all did the cheesy Olivia Newton-John bit in the middle of the dance floor.

It was gone midnight and The Salon was packed out after all. Until now, Sinead had danced herself into a daze and successfully blocked Travis out of her consciousness.

*'Oh yes indeed!'*

*'Ooh-hoo-hoo!'* they sang, arms raised above their heads, fully into the retro music.

*'You're-the-one-that-I-want!'*

Suddenly Travis pushed his way into Sinead's consciousness. Travis looking cool, surrounded by chicks on the fashion course. Travis close up and gazing at her with those eyes brown as hazelnuts, Travis laughing, Travis kissing her, touching her lips with that soft, full bottom lip . . .

*'Oh yes indeed!'*

Sinead stopped dead. She gasped, put her hand to her mouth and ran from the floor.

'Uh-oh!' Marina groaned, following Sinead to the ladies.

Which left Frankie dancing wildly in her pop-art dress, feather boa flying, sidestepping into couples, shooting forwards into a gap with her Travolta strut, striking a pose, *ooh-hoo-hoo!*

'Crazy lady,' a deep voice said.

Frankie opened her eyes, looked up and saw Juggler Man.

'Crazy dancing.' Wim was laughing, offering to dance the next slow number.

His laugh was deep and smooth, like chocolate. His eyes were grey. He was so-o-oh tall! Frankie fell into his arms.

'I'm such a bitch!' Sinead sobbed.

'No way,' Marina soothed, putting an arm round her shoulder. She was seeing more of the ladies loos in this place than she'd ever wanted. 'You're stressed out by Christmas, that's all. Everyone is.'

'I'm so mean to him!' Sinead blew her snotty nose then took a deep breath. 'And he's so kind

and understanding, until it came to this Dublin thing.'

'Travis is cool,' Marina said. 'He goes on a bit about cameras and stuff, but hey, that's his thing!'

'Daniella would hate it if I didn't see her over Christmas.'

'So go.'

'Without Travis?'

'Yeah, let him do his own family stuff, then meet up back here for New Year. Easy-peasy.'

Breaking free from Marina, Sinead pulled a paper towel from the holder and began to dab at her smudged mascara. 'I'm such a bitch!' she muttered.

'A tad high-maintenance,' Marina agreed with a grin.

Sinead caught her friend's shiny, smiling reflection in the mirror. 'Says the J-Lo of Central Fashion School!' she protested.

'Bling-bling – I'm just Jenny from the block!' Marina rattled her earrings, checked her lip-gloss and shook out her wavy blonde hair. 'Come on, girlfriend, let's go dance!'

\*

'I'm from Amsterdam originally,' Wim told Frankie. 'But I lived in New York, then in Barcelona and then I travelled round Europe for a bit. Now I'm here.'

And how! Frankie soaked up the deep voice with its foreign accent. *Don't make me wake up and find this is all a dream!*

'What do you do?' Wim asked.

'Fashion student. Jewellery mainly.'

'That figures. What year?'

'First. How about you?'

'I studied fine art, but I dropped out of all that academic shit. Now I'm a juggler.'

'That's what I heard,' Frankie admitted. 'How long have you been doing that?'

'I joined a circus in Barcelona two years ago.'

*Amsterdam, New York, Barcelona. You're-the-one-that-I-want, ooh-hoo-hoo!*

'You know Cirque du Soleil?' Wim went on.

Frankie nodded. She didn't, but she felt she should.

'Well, the same as that, but Spanish – kind of an alternative circus. No animals.'

'Cool!'

'I learned to juggle with balls, clubs, bowler

hats, fire. You name it, I can juggle it. Then last summer I was in Paris, outside the Pompidou Centre. You know it?'

*Paris even!* 'Yeah,' Frankie lied breathlessly. 'I saw you in college the other day.'

'At Central? I was meeting a friend – the guy I room with. Hey, crazy girl, what's your name?'

'Frankie.'

'Wim,' he said, smiling down at her.

Travis showed his digital pictures of Bad Mouth to Rob after the gig. 'They've definitely got something,' he agreed.

'The lead singer's great.' Rob studied the tiny screen.

'Not your usual pretty boy, but he's cool.'

'No way your average boy band.' Rob looked thoughtful. Sound lead guitar, pretty good bass, excellent drummer. 'Maybe we should set up a college gig for them.'

'Hey, Mister Entrepreneur!'

'Why not?'

'Yeah, why not,' said Travis slowly. Maybe it wasn't such a bad idea . . .

'Let's get past the heavies on the door and

put it to the band,' Rob decided, glancing over his shoulder to make sure Travis was with him. 'What have we got to lose?'

'Lee was there at The Salon,' Sinead said in the taxi home.

'I know, I saw him.' Marina checked her text messages, then texted Rob. U r plc or mn.

'He didn't look happy.'

'No, but Frankie did. I've never seen her go for it head-on like she did tonight.'

'She's usually the one with all the barriers up,' Sinead agreed. 'Noli me tangere!'

'Huh?'

'"Don't touch". It's Latin.'

'Oh yeah, I forgot you were fluent in a dead language!'

'Anyway, you know what I mean. Frankie has a warning sign a mile high that keeps guys away. But not tonight.'

'No, baby!' Marina agreed, grinning at Rob's reply – My pad 2.30 dnt b late. 'Tonight Frankie was in overdrive.'

'I feel sorry for Lee. He's had a thing about her since the beginning.'

'I'd say he's wasting his time, wouldn't you? Did she say Wim was walking her home?'

Sinead nodded. As the taxi drove into Walgrave Square, Marina asked the driver to pull up outside Rob's house. The light was on and the front door stood slightly open. 'See you tomorrow,' she told Sinead, racing up the path.

The taxi coasted on to the opposite side of the square. Sinead paid and stepped out.

She paused to look at the twinkling white Christmas lights, then shivered and opened her gate.

'Thank God! I'm freezing my bollocks off here!' Travis grumbled.

He sat on the top doorstep, huddled inside a jacket that was too thin for the time of year, a black woollen hat pulled low over his forehead.

Sinead smiled. 'You'll be no good to me, then!'

'Come on, unlock the door, I'll do Christmas your way, anything, anything – just let's get inside!'

She turned the key. 'Sorry,' she murmured.

'Yeah, yeah, me too – sorry, sorry!' Travis pushed through the door.

'Forgive me?' They stood in the warmth and the dark, their arms around each other. 'Are we back on?'

"Course we're back on! I love you.'

Travis and Sinead agreed – it was kisses like this that made breaking up worthwhile . . .

# THREE

'Kick him out,' Travis advised.

He and Rob sat with Lee Wright in Escape, the bar that Marina worked in, dead in the middle of the student area of the city. It was Saturday lunchtime and they were watching the football preview on the big screen TV.

Escape ~ Refuge ~ Getaway ~ Retreat ~ Shelter. The words appeared in giant letters across the etched glass windows. The inside of the room was decorated in leather and dark wood panels, with a steel and granite bar. Outside on the street, frantic Christmas shoppers trod through a dirty sludge of melting snow.

'Yeah, kick the Dutch circus freak out,' Rob agreed.

'What difference would it make?' Lee stared miserably at the pundits on the screen. 'She danced with him all night at this club we were at, then he took her home. It's obvious she fancies him.'

'Yeah, but if you chucked him out of your place he'd have nowhere to stay, so he'd have to move on,' Travis figured. 'End of story.'

'But she'd know it was my fault.'

'No, she wouldn't.'

'Yes, she would. He'd tell her. Then I'd be in deep shit.'

'. . . Everton are without two of their star players due to injury,' the pundit in the suit and flashy tie explained. 'They're third in the table, but today's match against Chelsea puts their recent record of three wins in a row in serious danger.'

'You're in it anyway,' Rob commented. 'Catch 22. If the Dutchman stays, he steals your girl. If he goes, you lose her.'

'Frankie's not really my girl,' Lee acknowledged. 'We went out a couple of times, that's all.' Once to see a Brad Pitt movie, once to the pub, then Frankie had gone cold on him.

'Frankie's not anyone's girl,' Travis pointed out. 'That's what I like about her, the free spirit thing.'

'How come Wim's staying at yours, anyway?' Rob asked.

'I bumped into him in Spain last summer. We hooked up for a couple of days, I gave him my e-mail address, we chatted online. Then he just kind of showed up.'

'How old is the guy?' Travis needed to check Wim out for Frankie's sake. He felt she needed someone to look out for her. 'What's he do for a living?'

'According to him, he's some kind of circus artiste,' Lee explained.

'Piss artist, more like,' Rob grunted.

'I reckon he's twenty-five or six.' Lee frowned up at the Everton manager who was being interviewed before the match.

'Twenty-six.' Travis shook his head. 'Frankie's only eighteen.'

'The guy's a cradle snatcher,' Rob said.

'Yeah, I don't trust him either.' Lee sighed, staring at the screen and acknowledging to himself that giving Wim van Bulow his e-mail

address on the spur of a drunken moment on a beach on the Costa del Sol was the worst move he'd ever made.

**I'm working tonight, sob!** Marina blogged. **It's December, there's a party every night, and I have to serve time as a barmaid to pay off my overdraft! Still, at least Rob's promised to come and see me at the place where I work.**

**You should know that I'm in serious debt. My lousy bank manager (a woman with a bad perm and a face like a sheep) won't give me any more money, and it's useless asking my parents ('For God's sake, Marina, do you think we have a bottomless pot of cash to draw on? We've already paid off three of your credit cards! *Blah-blah!*'). At this rate I won't be able to afford to eat.**

**Maybe that's a good thing – at least I'll go down a couple of dress sizes.**

**So, while I slave away behind the bar at Escape, Sinead and Travis are partying (Yes, folks, they're back together!) and Frankie's getting glammed up to go out with the Green Giant ('Giant' 'cos he's six–four, 'Green' 'cos,**

according to Frankie, he's a right-on Green Party activist who doesn't believe in GM crops and animal experiments and all that stuff).

F has developed a bad case of verbal diarrhoea: 'Wim – this, Wim – that, Wim, Wim, Wim.'

Was I as bad as that when I started going out with Rob? (Don't answer that!)

I reckon it's sweet, though. She never thought she'd meet someone she really fancied, and Sinead and I were always telling her it would happen sooner or later.

And just so you know it's the real thing – he's texted her four times since last night, and she's texted him right back. Tonight they're gonna meet outside the railway station at eight.

Watch this space . . .

Pressure, pressure, pressure!

For the first time since she started college, Sinead was late with an assignment. It was for the life-drawing module with Jack Irvine, and way down her list of priorities.

'Who wants to sketch saggy old bodies on a

beautiful Saturday three weeks before Christmas?' she groaned, saying goodbye to Frankie at the main entrance before heading towards the studio.

Frankie shrugged. 'Maybe the body won't be saggy. Just for once it could be young and lithe.'

'I *wish*!'

'Did you know Travis had volunteered to model for our group?' Frankie knew this would wind Sinead up. Travis was blessed with movie star looks and had a totally in-your-face openness about his physique. 'Seriously – he said we could draw him!'

'I'll kill him,' Sinead vowed. As if it wasn't bad enough, the way girls from every year and every course flocked round him. A warning – 'Beware – babe magnet!' – should be tattooed across his forehead.

Frankie laughed. 'So don't complain about the saggies!'

'Yeah, yeah.' Sinead set off down the corridor, then paused and turned. 'Good luck tonight, if I don't see you before!'

Tonight. The Big One. Frankie's date with Wim.

'Thanks,' Frankie choked, feeling her legs suddenly turn to jelly as Sinead hurried off.

The painting studio was a big, open room with a high ceiling and tall windows to let in maximum light. Today the model was a woman Sinead hadn't seen before – tall and solid, with wide thighs, small breasts and a helmet of short, ash blonde hair.

Sinead chose an easel and got to work alongside three other students – two from the second year and one postgraduate.

Jack, the bearded, grey-haired tutor who, several millennia ago, had studied fine art with David Hockney, was deep in discussion with the postgrad. 'A minor miracle is occurring at the start of the twenty-first century – painting the human figure is coming back into fashion! We all thought it was dead and in its grave, but no – Charles Saatchi, no less, is buying the figurative work of Jenny Saville and the like!'

Drone-drone-drone.

Sinead studied the model from many angles. Massive thighs anchored her to the ground, and yet the top half of her body seemed slighter, the

short haircut making her seem younger than she was. Interesting.

'Nice to see you, Mizz Harcourt!' Jack Irvine called across the room. 'Quite the stranger, aren't we? What is it – too many distractions out of school?'

'Yes,' Sinead said frankly.

'Boyfriends? Parties? Shopping? Life's a bitch for the young and beautiful!'

She smiled, then picked up a thick piece of charcoal and made her first marks on the A1 sheet. After all, this model was great. Her face had perfect repose.

Within five minutes Sinead was lost in the work.

*Light-tastic!*

Frankie studied the shots of the city's Christmas lights which she had on camera. She wanted to use them as inspiration for her next jewellery project, after she'd finished work on the ethnic theme. Satisfied with the photographs, she placed the camera on her workbench, next to her mobile phone.

*No new text from Wim.*

If she worked fast, she could finish a belt buckle that she'd begun a week ago from a design based on Native American beadwork set in heavy silver. The red, black and azure glass beads were tiny and difficult to handle, so the project needed patience and skill.

*Still no text from Wim.*

The main pattern was a black and bright-blue zigzag across a red background. Maybe she needed to add white beads to highlight the design? She stood back to consider this.

Her phone buzzed and vibrated sideways on the smooth surface. `Y not meet at Roundhouse instead xxx`

`Cool xxx`, she texted back. The Roundhouse was the building which Wim's circus troupe had rented to rehearse their routines. He obviously wanted to show her the group in action. Already she was floating, somersaulting and twirling through the day like never before. Now she felt she actually had wings!

'Are you busy?' Tristan Fox interrupted. He didn't wait for an answer. Instead he walked up to Frankie and made her turn around. 'You

have legs under those jeans, don't you?'

'I did last time I looked!' In fact, just this morning she'd waxed them and put on fake tan, especially for her date with Wim.

'Show!' Tristan insisted.

She rolled up one trouser leg.

'Good. Frankie, I want you to do something for me. Come on, darling, it's an emergency!'

She frowned. You didn't say no to Tristan, ever.

'I've just had a phone call out of the blue. They want me to do a photo shoot and they expect me to conjure a model out of nowhere. I said no, it was impossible at this time on a Saturday afternoon, but they wouldn't listen. They want the images on disk and e-mailed across the Atlantic before midday, East Coast time!'

'Who's "they"?' Frankie asked, trotting down the corridor to keep up. 'What's happening? Where are we going?'

'Clients in New York.' Tristan stopped impatiently outside the photography studio. 'Frankie, will you listen to what I'm telling you, sweetheart! I want you to model my latest shoe designs. It's very last minute. These are highly

important people. Now, will you do this for me, or do I have to trawl this godforsaken building and find someone else?'

They were the most wonderful, most gorgeous shoes in the universe. Hardly-there, strappy sandals in aquamarine blue with high gold heels and a dainty gold buckle – shoes that whispered money.

'Walk towards me!' Tristan instructed, camera at the ready.

Frankie did her catwalk strut, perfected along the landing at Walgrave Square.

'OK, good. Now turn and walk back!'

She grinned and wiggled away. 'Lucky they can't see what I'm wearing above the knee!' she giggled.

Tristan had told her to take off her jeans and top, and handed her a black bin-bag to wrap around her torso to protect her modesty. 'It's only the legs and feet we're interested in, darling!

'Stop! Turn again. Stop!'

Frankie tried to appear confident, though it was difficult wearing a black bin-bag.

*Click-click!* Tristan crouched down and zoomed in on her bottom half. 'Good legs,' he commented. 'Good posture. Good face, for that matter.'

*Hey, a compliment. In fact, three compliments!*

'Ever thought of modelling for a bit of extra cash?'

'Are you serious?' Frankie was convinced he was joking. If someone asked her to describe herself, she would say, 'Mega-untidy, scatter-brained, gawky disaster area.' Definitely not model material. 'My mouth's way too big.'

'There's no such thing,' Tristan contradicted. He'd finished taking his pictures and stood with his arms folded. 'The bigger the mouth the better. And wide-apart eyes and a high fore-head. You've got a very contemporary look, as a matter of fact.'

'I have?' Kicking off the precious shoes, Frankie struggled back into her jeans.

Tristan nodded. 'Leave it with me,' he said. 'I'll make a few phone calls for you.'

And before Frankie could stop him, Tristan headed off down the corridor.

*

The Roundhouse was down a dimly lit street in the old riverside area which had lately grown trendy and been transformed into an arty enclave stuffed with small galleries, boutiques and loft apartments.

Frankie didn't know it well, but recognised the old corn exchange building by its shape. Roundhouse really did mean 'round house'. Fantastic!

`Am scared witless!` She texted Marina and Sinead from outside the front entrance. It was five to eight.

`Go girl!` Sinead replied.

Marina was at work, too busy to text back.

*Pull self together! Take deep breath!* Frankie pushed the door open and stepped inside the curved building. *Find way to rehearsal room. Look as if you know your way around. Ignore strangers giving hostile stares.*

'Hey, crazy girl!' Wim strolled round the bend towards her wearing combats and a black T-shirt. His smile was warm and open, his grey eyes twinkled.

'Hey, juggler,' she replied, feeling her heart go into overdrive.

'Come see.' Inviting her into a bare room much smaller than she'd expected, Wim stood her by a wall.

A red-haired woman in a green leotard walked on her hands, as another girl did the splits. A guy in a black vest and shorts swung from a trapeze.

'Watch!' Wim said.

He took up a stack of multicoloured bowler hats and began to juggle. Throw-catch-spin-around-throw-catch.

Frankie grinned. The trapeze artist contorted his body and tied himself in knots while swinging upside down.

'Now this!' Wim chose silver clubs and sent them flashing in an arc over his head.

'Speed juggling!' Frankie applauded. The red-head cartwheeled across the room, met up with the trapeze man and the pair swung in tandem. The whole world had turned upside down. 'Too much!' she cried.

'Babe, you ain't seen nothin' yet!' Wim laughed at Frankie's wide-eyed delight.

'How was your day?' he asked at last, leading her out of the rehearsal room towards a

dingy bar further down the corridor.

'My day was cool. I did some work. Then I lucked out. My tutor promised me some modelling work.' *Oh, and I couldn't stop thinking about you!*

'That's cool. What would you like to drink?'

Frankie sat on a stool by the bar. It was empty except for them, and the place needed a major makeover. Its orange walls hadn't been painted since about 1970, which was roughly the date of its frayed hessian seating. It smelled of musty carpet and sweaty bodies. But it was Wim's world and she felt privileged to be given a glimpse.

'I was planning to take you dancing later,' he told her, over their glasses of luke-warm beer.

'But?' Frankie sensed there was a 'but' somewhere in there. Her soaring heart plummeted earthwards.

'I've just found out we're working late. Extra rehearsal. Sorry.'

Frankie managed a smile. 'That's OK.'

He studied her face, then put his hand to her cheek to brush away a stray strand of hair. 'But tomorrow we could dance.'

*Must not seem too keen!* Frankie reminded herself.

'Tomorrow's difficult,' she murmured.

'Monday then?'

'Monday could be good.'

'I'll call you.'

The beer trickled down Frankie's throat and sat uneasily in her stomach. What was going on here? If Wim was caught up in work, why hadn't he texted to postpone their date?

'Hey, I can't believe it – I'm going to be dating a supermodel!'

Her heart landed with a bruising thud. 'Don't hold your breath!' she warned. 'Tristan will most likely forget.'

'Yeah, the next Kate Moss,' Wim insisted, glancing at his watch. 'Sorry, I gotta go, Frankie. Listen, I'll call you tomorrow, OK?'

'Isn't that . . .? Yeah, that is! It's Wim What's-'is-name!' Sinead made out a super-tall guy across the small, darkened room.

It was two in the morning at someone's place somewhere in town. She and Travis had drifted from one party to another, too into each

other to notice exactly where they were.

'Yeah, but that's not Frankie,' Travis muttered. The Dutchman was dancing with a redhead, up close and very personal.

'How did that happen?' Sinead was suddenly sober. 'Oh my God, Trav, it really is him!'

Wim looked up and away from his dance partner and caught Sinead's eye. There was a glint of recognition.

'Where's Frankie?' she hissed at Travis. 'What's he doing with someone else? Listen, I've got to call her!'

Travis frowned. 'No, wait.'

'What for? I need to know if she's OK.'

'She's OK.'

'How do you know?'

'She'd have texted you if she wasn't.' Travis watched Wim say something to his girl then they pushed their way out of the room. 'Leave it, it's not our thing,' he insisted, frowning after them. 'Anyway, what are you going to tell Frankie? That her new Prince Charming is a dirty, low-down cheat?'

# FOUR

Marina leaned over the bar at Escape and handed Rob his bootlace tie with its engraved silver clasp. 'Wear it!' she ordered.

Rob stared deep into the cleavage created by her bright-crimson, wasp-waisted bodice. He went into a happy daze.

'Wear it!' she repeated with a smile, hooking one arm around his neck and lassoing him with the tie. It completed his American cowboy look, which consisted of Levis, white shirt, brown leather waistcoat and black stetson.

'Do I have to?' Rob sighed, content to stay lassoed and be kissed.

'This is fancy dress!' Marina insisted. 'I found this costume specially for you.'

'Who am I meant to be?'

'Wyatt Earp.'

'Am I a goody or a baddy?'

'Goody.'

'Who are you?'

'I'm your true love – the bar girl with a heart of gold!' Marina stood back and struck a crimson-and-black-lace pose. 'Complete with fishnet stockings and suspenders!' she promised.

'*Why* are you?' Rob badly needed a drink to get him through the night ahead.

'Because this is *themed* fancy dress,' she explained, serving beer to a customer. 'The theme is "You're History!" which means you can come as any historical character you want. Count yourself lucky – you could have been King Henry VIII in an embroidered codpiece and pantyhose!'

'Give me a pint, quick!' Rob groaned. 'If I have to meet the singer from the band dressed as a cowboy, I need to be smashed!'

'You drink way too much,' Marina complained, pulling a half and sliding it across the bar.

'Christ Almighty, what was that?' Rob stepped back to let a guy in a green dragon

46

costume waddle into the gents. His scaly tail got caught in the door.

'The other half of Saint George!' Marina giggled. That was nothing, she said. Hadn't Rob clocked the Elizabeth I in the corner?

'That's the guy from the gym in a red wig and drag!' he gasped. The dragon finally freed himself and made it through the door. 'Remind me not to go for a pee in the near future!'

Marina served a Bacardi Breezer to a woman wearing not much Greek drapery and a wig made of bendy, green plastic snakes. 'Hey, Sinead!' she said.

'Hey!' Medusa settled herself on a stool by the bar. 'Cool party!'

'You look stunning!'

'You're not bad yourself.'

'Where's Travis?'

'Sulking in a corner.' Sinead drank from the bottle, crossing her legs and letting the long, see-through skirt fall away to reveal yards of tanned bare leg and thong sandals, criss-crossed up her calves.

'Why's he sulking?' Marina asked, glancing across the room crowded with ape-men, flapper

girls, Vikings and an odd, lost-looking penguin. She spotted Travis in a chunky leather breast-plate, short skirt and Roman helmet. 'Your man has nice legs,' she commented.

'Mmm. He's pissed off because he thought the penguin was chatting me up!' Sinead sighed, then smiled.

'Was he?'

'Yeah.' Finishing her drink, Sinead slid from the stool and glided towards Travis, snakes writhing.

'I just decided something!' Marina announced to Frankie, aka Cleopatra, who had taken Medusa's place on the stool.

'Uh-oh!' Cleo said through half an inch of black eye make-up. 'Sounds serious.'

'It is.' With one eye on Rob, who had pushed through the crowd to meet up with the singer from Bad Mouth, she explained her mission to Frankie. 'Rob drinks too much. I'm gonna make him cut back.'

'Yeah, and I'm Giorgio Armani.'

'What do you mean?' Marina frowned.

'I mean, Rob wouldn't be Rob if he wasn't standing with a can of lager in his hand. Taking

him out of the pub would be like taking him out of his natural habitat. He'd get disorientated, confused, alienated – and soon he'd become extinct!'

'Hey, you're supposed to be on my side!'

Frankie shook her head. 'Listen, there are certain things in life that even *you* can't change, Marina. I mean, it's not as if Rob gets smashed out of his head and pukes up over the bedclothes every night, is it? And he doesn't drink and drive and stuff like that.'

'No, he leaves his bike behind when he comes out drinking,' Marina conceded. 'But I'm worried about his brain cells. He loses millions every time he goes over the limit. And he's not Einstein to start with – which is one of the things I like about him, don't get me wrong. But now he's talking about setting up gigs and doing more than just dee-jaying in his spare time, he'll need to stay sober, and . . .'

'Marina, stop!' Frankie raised both hands in defeat. She'd just had a text from Wim and wanted to reply. 'Do whatever you want. Turn Rob teetotal and get him to join the Salvation Army, for all I care!'

'I will!' Marina pledged, the glimmer of missionary zeal lighting up her eyes.

'A gig at the college?' Boz from Bad Mouth repeated. He was a skinny guy wearing a torn T-shirt, tattoos and plenty of body piercing.

Rob nodded eagerly. 'I talked to the guy who runs the entertainments committee in the students' union,' he assured him. 'They've had a cancellation. Can you step in at the last minute and do a gig for us next weekend?'

'Don't know about that, mate,' Boz grimaced. 'Christmas is a mad time of year for us.'

Saint George elbowed Rob in the back to get a place at the bar. Spotting Boz and recognising him, he leaned over and got him to sign a beer mat.

'Do it!' Rob insisted. 'You've got a solid student fan base in the city. I can guarantee you a sell-out, no problem!'

'Which night – Friday or Saturday?'

'Friday. The venue holds two thousand. We'll roll out the publicity extra fast, print the tickets, do all that stuff.'

'I don't know, man.' The singer still wasn't convinced. 'I need to ask the band, check it out, y'know.'

`Hey crazy girl`

Wim's text message made Frankie grin. 'Hey crazy girl'. That was all. She decided not to text him back – it wouldn't do any harm to make him wait for an answer.

Instead, she joined Snake-girl Sinead in a dance on the tiny dance floor. 'What's up with Travis?' she demanded.

'Still sulking.'

'What about?'

Sinead shrugged. 'I thought *I* was the moody one!'

'You are. You're both as bad as one another!' Sinead's snakes bobbed and Frankie's fake gold jewellery clinked. Everyone else on the dance floor paled into insignificance.

*OK, she's a total babe*, Travis acknowledged to himself. He knew all eyes were on Sinead, in the slinky drapes slit way up the thigh, with her bare arms, skinny shoulders and beautiful pale

face beneath the crazy snake-wig. *But does she have to flaunt it?*

*No, that's not fair,* he thought. The penguin was in there again, shuffling up close and poking his beak in Sinead's face. *It's not anything she does, it's just that she's the most gorgeous thing on God's earth! What do you expect if you go out with a goddess?*

He watched Frankie pause and take out her phone. Meanwhile, a guy dressed up as a highwayman, complete with black mask, cut in and started dancing with Sinead.

*She could say no,* Travis frowned. *She could be here, chatting with me, instead of dancing with any drunken bastard who asks her!*

## Hey Cleopatra

Frankie stared at the tiny screen and read the two words. How did Wim know about the Egyptian gear?

W h e r e   r   u, she texted back.

'Right here!' he said, looking over her shoulder.

'Aagh!' Frankie jumped a mile. Her jewellery rattled. 'What are you doing here?'

'Lee and I came in for a drink,' he laughed. 'At first I didn't recognise you, but Marina told me you were here as Cleopatra. "The barge she sat in burned like beaten gold." Do you know that? "Purple the sails, and so perfumed that the winds were lovesick with them!" or words to that effect.'

'Hold it!' she cried, backing off as if overwhelmed.

'Shakespeare. *Antony and Cleopatra.*'

Frankie caught her breath. 'How come they let you in without a costume?' In his jeans and cool grey sweatshirt he stood out from the crowd of royals in nylon wigs and axe-wielding, horned marauders.

Wim shrugged. 'Did you make your own?'

'Yeah, out of gold foil from chocolate bars. I wrapped it round sets of draughts and dominoes, then strung them all together and decorated an old blue bikini top I had stuck away in a drawer . . . Uh-oh!' Frankie grimaced. Too much information. Excitement always made her spout nonsense. Wim was here, out of the blue, grinning down at her. She wasn't meant to be seeing him until tomorrow night!

'You should have come in historical dress,' she told him.

'Like I said, we just dropped by for a drink.'

The other half of the 'we' approached with two beers. 'Here, you have this,' Lee told Frankie, offering her one of the cans and giving Wim the other.

'Thanks, Lee.' Underneath her make-up, Frankie blushed.

'Egyptian suits you. You look cool,' Lee told her.

'Thanks.' *Don't be nice, be mad with me!* Frankie thought. *I can't stand nice!*

'I'm gonna see how things are working out for Rob,' he muttered. 'Since I'm on the union committee, I want to see if he got the gig.'

'Committee man!' Wim raised his eyebrows as Lee walked away.

'He's cool,' Frankie insisted, drinking the beer that Lee had given her.

Wim cocked his head to one side. 'Meaning?'

'Nothing!'

'Hey, I'm not treading on anyone's toes here, am I?' Wim sounded as if a new idea had just hit him between the eyes and was ready to step

back if Frankie asked him.

'No way!' Bloody Lee – she'd kill him for being nice to her and making her feel guilty. 'Let's dance,' she said.

'No, honestly, he didn't try anything,' Frankie told Marina and Sinead on the bus on the way to college next morning. 'Wim's walked me home twice now, and both times I got a quick peck on the cheek, and that was it. Except afterwards, I get loads of e-mails and texts.'

'Perfect gentleman,' Sinead commented flatly.

'Why, what's he done to you?' Frankie asked.

'Nothing.'

'Why the sarcasm, then?'

Sinead thought of the redhead at the party on Saturday night, and the body-hugging clinch. 'No reason, forget it.'

Meanwhile, Marina analysed the two pecks on the cheek. 'He's an older guy, see – they're more mature. They don't have to rush things and make a grab too early in the relationship.'

'I guess,' Frankie said with a small frown. 'You don't think it means he doesn't fancy me?'

'Babe, he fancies you,' Marina insisted. 'I saw the way he danced with you last night!'

The bus swerved in to the pavement and collected more students and office workers from the stop.

'He talks about stuff I've never talked to anyone about before,' Frankie sighed. 'Painting and sculpture, and the theatre. Do you know, he once went to a performance art thing in New York where this naked guy smeared himself in buffalo dung then rolled on a blank canvas spread out on the floor . . .'

'Puh-lease!' Marina groaned. 'Think of my breakfast!'

'You didn't have any breakfast!'

'Exactly. I was gonna grab a piece of toast and a coffee when I got to college. Now I couldn't eat a thing!'

'God, that's revolting!' Sinead told Frankie. 'I mean – buffalo dung!'

'Wim said it was connected with the white man's guilt about destroying the buffalo in North America, and the artist was abasing himself as a kind of penance . . .'

'Penance, bollocks!' Sinead shook her head.

'Are you still seeing him tonight?' Marina asked quickly, recognising their stop and jumping up from her seat.

Frankie and Sinead followed down the crowded aisle.

'Wild buffalo wouldn't stop me!' Frankie told them. 'We're meeting at eight for coffee.'

'Sinead, today I'd like to see you develop your pirate theme in more detail,' Tristan said at the start of the fashion design workshop. 'Investigate some fabrics, look in the history books for the cut and detail on the original garments.'

'I already did that,' Sinead told the tutor. She showed him drawings of laced fastenings and carved buttons. 'The shirts had really fine gathers at the neck and sleeves.'

'Good. But you're still thinking in terms of white. Try a new colour – a shirt in lime green or orange, something that zings. Get away from your usual neutrals.'

As Sinead bent her head over her drawings, Tristan strolled on. He commented on the cropped jacket and super-wide pants designs of

another student, encouraging her to experiment with proportions and novel combinations. 'Play!' he instructed. 'If not now – when?'

Then he came to Frankie and her ethnic sketches incorporating beads and batik prints.

'Take it further,' he recommended. 'Bigger beads. More fake jade and coral, and make the bandeau tops skimpier.' He stood back for a moment, arms folded. 'Interesting – I've recently seen designs at Blumarine and Roberto Cavalli that play with the same theme.'

Frankie nodded. No news about the model agency, then. Typical Tristan – all promise and no follow through.

'Oh, by the way,' Tristan said as he moved on, taking a business card from his lilac pinstripe shirt pocket, 'I want you to go and see Jessica West later this afternoon. She runs the Bed-Head Agency. This is her address.'

'Travis, pinch me, smack me on the cheek, convince me I'm not dreaming!' Frankie raced up the steps into Number 45 Walgrave Square. She followed the smell and sizzle of burgers being fried.

Travis glanced round. 'If it's love stuff, you chose the wrong person to tell right now.'

'What? Why?'

'Oh, Sinead and I just had another row.'

'Oh. No, it's not. It's work stuff. Well, kind of.' Flinging her bag down on the cluttered table, Frankie paused for breath. She could still hardly believe what had just happened.

Travis lifted one burger and flipped it onto a bread bun. He mulched it with ketchup and fried onions, slapped down the lid and bit into it. 'Someone commissioned you to make them a necklace,' he guessed.

'No. When I say work, it's not jewellery designing. It's fashion-related though. Go on – guess!'

'Do you want a burger?' Travis offered.

'Travis, concentrate! Oh anyway, I'm gonna tell you whether you like it or not. I just went to a model agency and they took one look and said they'll put me on their books!'

'Travis says he'll take the photos I need for my portfolio!' Frankie told Sinead. She'd found her downstairs at Number 13, sitting on the floor in

59

the front room, sketches spread out around her. 'By the way, what did you and Travis argue about this time?'

'Dunno. He's in a mood with me, that's all.'

'Well, I think you should kiss and make up. Listen, Travis will take the pictures and not charge me anything except the cost of materials. But God, I'm so freaked out! I went to meet this Jessica woman, and she's so not what you'd expect. Y'know, she could be your mother. Well, not *your* mother, Sinead, but mine, say. Kind of ordinary and older, but dead businesslike, and she's been running this agency for decades . . .'

'Stop!' Sinead pleaded.

'Sorry. But Jessica said she could definitely find me work if I put a portfolio together, so Travis and I have got to get moving on it, and now I'm freaking out because I didn't think modelling was my thing. I mean, would you say I was model material, honestly?'

Sinead leaned back against the wall and grinned at Frankie. 'Babe, I'd say you were the next big thing.'

'No, really?'

'Really! Look at you.'

Frankie studied her reflection in the long bay window. Faded jeans torn at the knees, baggy black cashmere sweater, size – extra large, which she'd picked up for pennies at a charity shop, wacky home-made bracelets made from raw chunks of jade and silver. Her long dark hair was tied back at the nape but escaped in wild tendrils. 'Scruff-tastic!' she moaned.

'Move over, Naomi Campbell, is what I say,' Sinead smiled.

'The world of glamour opens up for Frankie McLerran!' Marina said in a tone of high drama. She was in her room, trying to finish an essay. But she switched to her blog site and began typing: **Designer Dreams!** she began. **Hold the front page. My friend Frankie has joined the legendary Bed-Head model agency. Will she still talk to me when she's rich and famous, or will she blank me at the Paris fashion shows and on the catwalks of New York?**

'Can you believe it's actually happening!' Frankie sighed. She flopped down on Marina's bed, exhausted. 'Marina, if I can get snapped up

by Jessica West, just think what would happen if you and Sinead went along!'

Marina closed her site. 'Frankie, you're really sweet to say stuff like that, but sometimes you can be so dumb!'

'How come?'

'Because, now that you're a model, you have to be a complete bitch. It goes with the territory. You have to put the rest of us down and fight like a cat to keep potential rivals away. That's how it works.'

'I'm not a model – yet.'

'Yes, you are.' Marina shook her head and smiled. 'I know you don't believe us, Frankie, but you've got it all. The shape, the hair, the face, the eyes . . .'

'Stop, please!'

Marina took up a pillow and bashed Frankie in the stomach. 'Get used to it, girl – the world has just become your great big, juicy oyster!'

# FIVE

'Tell me this is gonna work!' Rob pleaded with Marina. He'd got the super-fast go-ahead for the Bad Mouth gig, but it was already Monday night and the posters weren't out yet. He had a pile stacked by the college printer, which was still spewing them out.

Marina picked one up. 'Cool,' she commented, giving him a quick kiss. 'Where are you going to put them?'

'Everywhere. In all the corridors, on the doors, in the student bar.'

'Will you fly-post them in town?'

Rob tapped the side of his nose. 'Don't ask!'

Marina's eyes lit up. 'Can I help?'

'Aren't you working tonight?'

'Working, as in "behind the bar"? No.' *Sod the*

*essay*, she thought. *I'm already ten days late. What difference does one more day make?* 'C'mon, give me some posters. It's dark. I can start sticking them up in bus shelters while you finish off here.'

Maybe Sinead went around faking it most of the time, putting on an act that she wasn't hurting inside. She got that from her mother, Daniella, the Ice Queen. But the pressure of the problems with Travis was beginning to get to her.

'Why don't we go to Escape for a drink?' she suggested, after a full hour of near silence at his place.

'Nah, it'll be dead on a Monday.'

'Let's just go for a walk then.'

'Bloody freezing.'

Sinead stared out of the living-room window. Under the orange street lamps what was left of the weekend snow looked dirty and miserable. 'Daniella texted me today,' she told him.

'Huh.'

'Why so edgy?'

'Daniella, the Dragon Lady.' Travis disliked the way Sinead's rich and snobbish mother had

her daughter dangling on the end of a string.

'She *is* my mother, y'know. Anyway, it turns out she's going to be in Prague with a friend over Christmas, so I can come with you to your parents if you want.'

Silence from Travis.

'Aren't you pleased? I thought that's what you wanted.'

'Want*ed*!' He stressed the second syllable. 'As in, past tense. But you made it pretty clear that being with my family wasn't your idea of a good time.'

Sinead closed her eyes and frowned. 'Trav, that's not fair. You know it was Daniella that I was worried about.'

'Yeah, and look what she does to you! Anyway, why can't you call your mother "Mum", like everyone else? How come it's all this matey-matey stuff with you two?'

'Now you're really out of order.' Instead of letting him see she was hurt, Sinead got up from the sofa where they'd been watching a boring action-hero video.

'Where are you going?' he asked.

'Home.'

Her action worried him. Suddenly he was alert, studying her face and trying to judge her mood. 'Don't go.'

'Why not? If I stay you'll just sit there and insult me.' In October, when they first got together – even up to a couple of weeks ago – Travis would never have treated her this way. In the beginning he'd been so gentle and considerate, seeming to understand her fears and insecurities. Sinead grabbed her jacket and put it on.

'Don't!' Travis repeated. 'Listen, I'm sorry. I'm just in a bad mood, that's all.'

'Yeah, you've been acting like this for the last month.' It was no good, she was too upset to accept the apology. 'I never know where I am with you! Like last night, at the stupid fancy dress thing, you hardly talked to me.'

'*Me?*' His jaw dropped. 'Funny, I thought it was you out there dancing with every sad bastard who asked you while I was stuck in a corner.'

She marched to the door. 'Don't be so childish. I can't talk to you when you're being like this.'

Travis leaped over the back of the sofa and

blocked her exit. 'Isn't this what you always do – run away when the going gets tough?'

Sinead shook her head. 'I'm not listening. The truth is, a guy just has to *look* in my direction and you go into a massive sulk with me. What am I expected to do, go around in a granny cardigan and sheepskin slippers, for God's sake?'

'Oh, so now *I'm* the insecure one, am I?' He held fast to the door handle so she couldn't open it.

'Travis, let me out. Yes, as a matter of fact you *are* insecure. And listen, I don't *do* jealousy! Not any more, not since we had that stupid thing at the beginning about an ex-girlfriend of yours and we both agreed what a waste of time it was.'

He dropped his gaze but held tight to the door.

Sinead stood back. 'What's happening to us?' she asked in a shocked voice. 'I thought you were the laid-back guy with a camera, too cool for school.'

'I was,' he admitted. He let go of the handle.

'You said you loved me. I thought you did.'

Tears filled Sinead's eyes. She saw him looking lost and wounded.

He felt helpless. 'I do love you.'

'But it's not working, is it?' *Say, 'Yes it is working,' please!* Sinead held her breath and prayed. *Say it again. Say you love me and mean it!* Her heart beat fast as a cat's.

Travis turned away from the sight of her tears. 'I don't know.'

'This is serious. You're breaking my heart. I'm not the sort you can blow hot and cold with – it's like, I don't know – like I don't have enough layers of skin to cope.'

He nodded, already knowing this about Sinead. 'Do you realise how beautiful you are?'

'What's that got to do with it? I'm trying to tell you how I feel deep down. What does how I look have to do with it?'

*Like a fallen angel. Blonde and perfect, with great big, sad eyes.* 'Everything,' Travis whispered. *Guys come swarming to the honeypot.*

Sinead steadied herself, rubbing the tears from her face with the back of her hand. 'I think we should take a break,' she said quietly. 'A real one this time. I mean it.'

Travis stood aside. He heard the click of the door, her footsteps going down the hallway, then the heavy thud of the front door as it closed behind her.

Charisma. That's what Wim had, in spades.

Frankie sucked the froth from her cappuccino and watched him entertaining the girl behind the counter.

'Did you know there was a hair in my coffee?' he began in a brash New York accent. He pretended to take a closer look, then dipped in his fingertip. 'Uh-oh, it's mine!'

The girl stared at his close-cropped head, did a double take, then laughed.

And he was so sexy, Frankie decided. Sexy in the style of a professional footballer, quite raw and rugged. But he had brains too, and he knew so much.

'How's my crazy girl?' he asked as he brought his coffee over to her table and sat down.

'Good!' she grinned.

'Or should I say my super-model?'

'Crazy girl is fine.' Frankie wasn't counting any chickens on the modelling front. 'There're

a million girls like me out there.'

'Yeah, but you're in the right place at the right time,' Wim convinced her. 'That's what success is – five per cent talent and ninety-five per cent luck.'

'So where does the work and dedication come in? You must have trained really hard to do what you do.'

He laughed. 'I was born with it! No really, all you need is good hand-eye co-ordination.'

'But don't you get nervous, standing up in front of hundreds of people?' Frankie could see others in the coffee bar eyeing Wim up. Was it his height, his film-star face, his laid-back jokiness, or just the whole package?

'No, I have a giant ego,' he laughed. 'I love to be the centre of attention.'

'Truly?' This was the bit about modelling that bothered Frankie. People staring at her, judging her, looking for defects.

'Come on,' he suggested, standing up and taking her by the hand. 'Drinking coffee is boring. Let's go and find some action.'

Frankie floated on air through the Christmas

streets. Santa was on his sleigh in lights over-head, giant stars twinkled, angels flickered their wings.

'Hey, there's one of Rob's posters!' She pointed to an advertising board covered in tattered bills. The Bad Mouth college gig poster was big, bright and bold.

Wim stopped to read the details. 'We could go, if you like.'

Her eyes widened. She smiled and nodded.

'After I finish at the Roundhouse.'

'More rehearsals?'

'Yes, but I could meet you at midnight. You go early, and I'll see you there.'

'Cool.' Her hand fitted nicely into his; she didn't feel gawky beside him as she did with most men.

'Where do you want to go now?' he checked. 'I'd ask you to my place, but I get the feeling things are awkward with Lee.'

'True,' she sighed. 'Maybe mine, then?'

A bus ride later, they were walking across Walgrave Square. 'The lights are on in the house. That must be Sinead,' Frankie predicted, knowing that Marina was out helping Rob.

Inside Number 13, music was playing quietly in the front living room.

'Nice place,' Wim commented, unzipping his big jacket and taking in the broad bay window, the big sofas and the artwork on the walls. He looked hard at two large canvases of female nudes. 'Who did these?'

'They're Marina's, one of the girls who lives here. She's really talented.' Slipping upstairs to Sinead's room, Frankie found the light off and Sinead motionless under her duvet. She went down to the kitchen, found cans of cold beer and took them to Wim. 'Sinead's asleep,' she reported.

'Just us, then.' He invited her to snuggle close on the sofa, one arm around her shoulder.

Frankie snuggled. *Unbelievable!* she thought. *What an incredible, wild, crazy day!*

Upstairs, Sinead lay completely covered by the bedclothes, listening to the murmur of two voices. That used to be me and Travis, she thought, eyes open, heart broken.

# SIX

'Wear stuff that you like,' Marina advised Frankie as she packed her bag for the photo shoot with Travis. 'Do your ethnic thing – it's very now.'

Frankie rummaged for her chunky pink quartz bracelets. 'I can't find anything in this mess!' she wailed.

'Stop panicking. Take this silk pleated skirt – bronze is a good colour. And this cream camisole. You can add funky jewellery. And you should borrow shoes from Sinead. Wait here, I'll go and ask her.' The picture of calm practicality, Marina went off.

'Oh God, I'm late!' Frankie shoved make-up and hairbrush into the bag. 'Tell Sinead not to bother looking!' she yelled, taking the stairs two

at a time and slamming the front door as she went.

'Look blank!' Travis ordered. He'd managed to stop Frankie from fidgeting in front of the camera lens, but her face was still way too animated. 'Pretend you have zero brain cells. Now, walk towards me!'

Frankie tried to clear her head. She shoved her shoulders back and strutted.

'Great. Keep on coming. Good, head down a bit, stare right at me, don't blink!'

She tilted her head, perfected her pout, arrived and stood with one hand on her hip while the shutter on Travis's camera whirred and clicked.

*Wim was a cool kisser. Soft lips. Gentle pressure. Wooh!*

'Frankie, stop looking so pleased with yourself. You're supposed to keep your face straight while we're working,' Travis nagged her, glad to have his mind taken off the split with Sinead. He hadn't told Rob yet, and he wondered if the news had got around the girls at Number 13. He hoped not. Somehow, if the

situation stayed secret, it was almost as if it hadn't happened.

'Thanks for doing this for me,' Frankie said.

'Hey, we're mates.' Travis stopped to change his film. 'And I'm a photography student, remember. Anyway, I really hope this works out for you. Before you know it you could be jetting off to the Maldives on location!'

'In my dreams!' *Wim didn't push it too far last night, but that was definitely more than a peck on the cheek. No grabbing and mauling. Not further than he knew I was comfortable with.*

All set to go again, Travis aimed his camera. 'Nope, Frankie, you're still way too happy.'

'So tell me something serious.'

'OK, then. Sinead and I have split.' In spite of his reticence, the words came to his lips. It was like that with Frankie – Travis had always spilled out whatever was on his mind.

'No!' she gasped.

'Last night. Didn't she tell you? I'm a bit messed up about it, to be honest.'

'Oh, Travis, I'm not surprised! What happened?'

'Dunno. All my fault, I expect.' Automatically

he went on taking pictures while they talked. 'I've been a moody sod.'

'That's not like you.' She saw the first male friend she'd made at college as totally comfortable with himself, so laid back he almost fell over. Forgetting the camera, she looked intensely at him. 'Do you want me to talk to Sinead for you?'

He shook his head. 'That's a good angle, hold that one for me. Now wait a sec while I fix this light.'

'I'd do that, no problem. She might listen to me.'

'No thanks.' Travis took new light-readings close to Frankie's face. 'Let's talk about something else. How's it going with the tall Dutchman?'

'Pretty good,' she admitted. 'We're going to the Bad Mouth gig together on Friday.'

Rob and Marina had practically papered the college walls with posters. Lee, who was in charge of ticket sales, said they were being sold as fast as he could print them. 'Brilliant idea of yours, mate,' he told Rob in passing. 'It's gonna be the

best end-of-term gig we've ever put together.'

'Event organising is your forte,' Marina told him. 'It's what you're good at.'

'I know what "forte" means,' he grumbled. 'I'm not just a rag-arsed lab technician, y'know.' Still, he could relax, knowing that he'd made a sound decision. He picked up one of the sheets of paper Marina had spread out on the table in the coffee bar. 'What's all this?'

'I have to apply for work experience for next spring. Boring, boring.' Filling in forms was *not* what she wanted to be doing. There again, she was trying for a mega placement, either at Vivienne Westwood's dress-making workshop, or with Emanuel Ungaro in Milan. She had to sell herself hard and get good references from her tutors. 'I can't get this lot off my mind,' she explained. 'I go to bed at night and I dream of seams and scissors. The fact is, you have to know all that basic stuff before you can expect to get anywhere in the fashion world. Rob Evans, what are you laughing at?'

'You,' he grinned. 'Before I knew you properly I had you down as a shallow, two-dimensional bimbo.'

'I hate you!' So what if she styled her hair and glossed her lips before she went to Tescos? That didn't necessarily make her brainless.

'Now look what I'm stuck with.'

'What?'

'Ms Serious Fashion Designer. Ms Ambition.'

'And what's wrong with that?'

'Nothing.' Jack Irvine, Marina's life-drawing tutor, cut in as he took his coffee cup back to the counter. Jack was an old-school, fine-art nut who didn't hold back on his opinions. 'Except that it's a complete waste of real talent,' he told Marina before he stamped off, trailing the smell of turpentine and oil paint after him. 'What you *should* be concentrating on is developing your painting technique. Visiting art galleries, reading some books.'

'Really?' Marina was taken aback by her drawing tutor's belligerent tone.

'Yes, really,' he insisted. 'Come off it, Marina; you know you're worth a hundred of those other fashion-obsessed airheads on your course.'

All day Sinead had avoided going to the places

she thought Travis might be. It had taken all her willpower to drag herself into college, and it was only the fact that she had to get an assignment back from Tristan that made her show her face at all.

'What's up, are you ill?' Marina had asked as they travelled in on the bus together.

Sinead had shaken her head.

'You're doing pale and interesting pretty well for a girl in the full bloom of health,' Marina had insisted.

But Sinead hadn't confided in her. *I'm sick of always talking about myself*, she thought miserably. *And who wants to hear lousy news just before Christmas, anyway?*

'You and Travis *are* coming to the gig on Friday, aren't you?' Marina had checked. 'I'll get you backstage passes if you like.'

Sinead had just managed to stagger off the bus and into her tutor's room, where Tristan had noticed her hands shaking and gone off to fetch coffee. 'You're not doing that eating disorder thing that seems to affect so many first years?' he asked her suspiciously.

'No, I'm fine.' She just wanted to get back her assignment and get the hell out of there.

'How's your mother?' he asked conversationally.

Tristan and Daniella went back a long way. He'd designed the shoes and going-away outfit for Daniella's first wedding, and they'd hung out together in the same social crowd. 'She's fine, thanks. She's going to Prague next week.'

'Tell her to wrap up warm.' Tristan searched for Sinead's folder on his desk. When he unearthed it, he opened it and reminded himself. 'Oh yes, I liked this a lot. The brief was to design an evening dress and you certainly put a lot of yourself into this one. It's very successful.'

'Thanks, I enjoyed doing it.'

'The presentation is good. I like your selection of sample materials, especially this slate grey chiffon – very distinctive, especially when you team it up with the narrow silver trim. And you swathe the fabric into a very nice bell shape for the skirt, keeping the midriff plain and semi-transparent.'

Gradually Sinead absorbed the praise. It warmed her and cheered her up. 'I want to

gather the hem so it puckers slightly. I think you can do that with a delicate fabric like chiffon.'

Tristan nodded. 'I'm glad you kept away from glitz. That's always the temptation with evening wear. Did you see them looking like Christmas trees, all lit up at this year's Oscars? And those are women with stylists who should know better!'

Sinead smiled briefly. 'What grade did I get?'

'Straight A,' he told her, folding the work and handing it to her. 'You're heading for a distinction at the end of this year, so long as you keep up this standard.'

*Grade A student, but I get D– for relationships.* Sinead walked into town after her interview with Tristan. *So what do I learn from that? Stick with fashion design, I say.*

She passed the shop windows aglow with gifts. It all meant nothing, when it came down to it. Christmas came, people gave each other stuff, usually smelly, that they didn't want, and ate too much, then it was over. And this year it looked like Sinead would be spending the festive season alone in Walgrave Square, since

Marina and Frankie had probably already made plans to go back to their own families.

*I guess I can work,* she thought. *I can focus on my next project. Hey, I might not be able to control what goes on in my love life, but when it comes to fashion, I can make damn sure I work hard and do well.*

The idea made her feel better. She decided to detour to the central library to check out some back copies of the fashion mags, which took her past the Roundhouse. And who should she see coming out of there with his arm around a cute blonde girl but Wim. The pair were chatting and laughing so hard they wouldn't have noticed Sinead even if she *hadn't* ducked into a shop doorway until they'd passed.

'Two-timing rat!' she muttered under her breath, turning back for college and half running down the street. 'For Chrissakes, just how many women does this guy have?'

# SEVEN

'But Frankie is so happy!' Marina protested. 'I've never seen her loved up like this before.'

'Exactly. That's my point.' Sinead had cornered Marina in the cutting room on the top floor of the college building. She'd told her all about the redhead and now the blonde. 'I think we should let her know before she gets in any deeper.'

Marina sighed as she doodled on the tracing paper she was using to make pieces for a jacket design. 'I know what you're saying, but let's think this through.'

'What's to think about? I've seen Wim two-timing Frankie on two separate occasions. The man's a love rat.'

'Yeah, but what right do we have to interfere?'

Marina was all for letting people live their own lives. 'Think about it – I wouldn't exactly thank you if you came and said Rob was cheating on me, even if it was true.'

'But if it happened to me, I'd want to know!' Sinead was sure that letting their friend in on Wim's womanising was the kind thing to do. 'What if Frankie falls deeply in love with the guy, *then* finds out what a slimeball he really is, and we say, "Yeah, we knew that all along"? What then?'

'I dunno, Sinead.' Troubled, Marina gazed out of the tall window, down onto the city streets. 'What real evidence do we have?'

'One, he was dancing with the redhead when he told Frankie he was rehearsing.'

'Maybe the redhead works with him. Maybe they went partying after rehearsal to unwind, like you do.'

Sinead shook her head. 'No way. Two, I just saw him with his arm round a blonde. They were really into each other!'

'It's not a capital offence,' Marina pointed out. 'Maybe that's just Wim's way. Some guys are touchy-feely, but it doesn't mean anything.

Honest, Sinead, I don't think we should ruin Frankie's chances because of this.'

'Don't you care that she's going to get really hurt?' Marina hadn't actually seen Wim with the two other girls. If she had, she wouldn't be holding back like this.

'I care that she's got a chance of happiness,' Marina insisted. 'Frankie deserves it. You know how shy she was when she first came. She couldn't even get through the door of the jewellery workshop because of panic attacks. Now she's on a total roll—'

'But!' Sinead cut in, then pulled back. 'Oh God, Marina, what are we going to do?'

'Nothing right now,' Marina said, drawing concentric circles, like ripples, on the paper. 'Or maybe something devious, so we can find some real proof.'

'Devious? What do you mean?'

Marina tapped the point of the pencil on the table. 'Leave it with me,' she said.

On Tuesday evening, the day after the split with Sinead, Travis took refuge in beer and footie. He watched the England-Holland match alone, got

through three cans and was only half listening to the pundits wittering on in their post-match analysis when Rob came in.

'What was the score?' Rob asked, chucking his bike helmet down on the sofa next to Travis.

'Nil-nil. We were rubbish.'

'Glad I missed it, then.' Rob caught the can which Travis threw in his direction, opened it and took a big swig. 'You look rough. By the way, I saved two tickets for you and Sinead for the gig this Friday. I take it you're coming?'

'Dunno, mate. Don't think so.'

'Where is Sinead, anyway? I haven't seen her lately.'

Travis closed his eyes and rested his head back on the sofa cushion. 'Me neither,' he admitted, giving Rob time for this snippet of information to sink in. There was silence except for the zip of Rob's leather jacket. The jacket landed alongside the helmet on the sofa.

'Did she leave for Dublin already?'

'No. She's not going home for Christmas now.'

Rob swigged again from the can. 'Is she sick?'

'Nope.'

'So how come you haven't seen her? Uh-oh.' Suddenly Rob clicked.

'Yeah,' Travis acknowledged. 'She chucked me.'

'Never!' Rob had Travis and Sinead down as serious soulmates. They went everywhere together and were all over each other every time they got the chance.

'Yesterday.' Travis couldn't say much. The words seemed to stick in his throat.

Another silence. Rob strode into the kitchen and opened the fridge. 'You look as if you need another beer,' he told Travis. 'Here, cop hold of this.'

Early on Wednesday morning, Frankie had skipped Claudia Brown's class to drop off her portfolio at the Bed-Head Agency. A blasé receptionist had taken it and promised to hand it to Jessica West in person.

'I'd rather give it to her myself,' Frankie had ventured.

'She's not in.' The receptionist had tucked the portfolio under her desk, along with an untidy

stack of others that Frankie caught a glimpse of.

'Shall I ring her later?'

With a twitch of a slim, arched eyebrow, the receptionist had indicated that this wouldn't be necessary. 'Jessica's busy with meetings all day today.'

So Frankie had slunk away dejected and, worse still, she'd bumped into her jewellery tutor on her way into college.

'Oh, I see you finally managed to crawl out of bed!' Claudia said, her fierce dark eyes dismissing Frankie as just another work-shy no-hoper who had been partying too late the night before. 'I handed back assignments in the class and gave valuable feedback which you missed.'

'Yes, I'm sorry. I had to do something important.' *Big mistake!* Frankie drew a sharp breath.

'Nothing, I repeat *nothing*, is more important than your work here at college,' Claudia insisted.

Frankie found the guts to stick up for herself. 'It was kind of connected. Tristan helped me get on the books of a model agency and I had to drop off my portfolio. If I can earn money modelling, it'll help pay my tuition fees.'

'Puh!' was all Claudia said, walking briskly on. Then she paused. 'Don't let it go to your head,' she warned. 'Modelling is notoriously unreliable work. The competition is fierce.'

'I know,' Frankie admitted, already feeling crestfallen by the reaction of the bored and unimpressed receptionist at the agency.

'And whatever you do, don't let that nonsense interfere with your college work in future,' Claudia instructed, walking on, as brisk as a sergeant major.

It took a text message from Wim shortly after that to raise Frankie's spirits to somewhere near normal again.

`How r u. Miss u. Have show 2nite and 2mrow. C u Fri xxxx`

Devious was what Marina did well.

'Never go at something in a straight line when a wiggly one works better,' she'd told Sinead after a whole day of thinking what to do about the problem with Wim.

In fact, Marina was all wiggles and curves, in the way she looked and the way she thought. 'If you suspect the Dutchman is cheating on

Frankie, you have to trust me to find out for sure.'

'How?' Sinead wanted to know.

'I don't know yet. I don't plan these things. But some useful situation will come up, and when it does, I'll go for it!'

For instance, Marina had a free afternoon. Rather than waste it, she helped Rob by counting the money they'd taken so far for the Bad Mouth concert.

£1765, she texted.

Great we r in2 profit, he texted back. Then Can u go 2 Lee's flat 2 pick up xtra tickets

That was it. Marina shot straight over to Nugent Road, where the door was opened not by Lee, but by Marina's unsuspecting quarry, Wim van Bulow.

'Hey,' Marina said. 'Is Lee in?'

'Who wants to know?' Wim asked, leaning against the doorpost, arms folded.

'A friend,' she said guardedly, waiting to know if he made the connection between her and Frankie.

'Lee's a lucky man,' Wim grinned, still blocking the doorway.

'How come?'

'To have you as his friend.'

*Yuck!* Obviously he didn't connect her, because he was already coming on strong. Marina suspected from the unfocused look in his eyes that he'd been drinking or taking something.

She decided to go ultra girly with her eyelashes and smile. 'Lee does live here, doesn't he?'

'Not such a good friend, then, if you haven't been to his house before.'

'I know him through college. Is he here?'

'Unlucky for him, no,' Wim told her, finally stepping to one side. 'But lucky for me. Come in. Can I help?'

Marina followed him into the narrow hallway and did more flirty eyes. 'Are you Lee's flatmate?'

'Yeah, Wim.'

'Hi, Wim. I came to collect something, but since Lee's not here, maybe I'd better come back later.'

'Stay for coffee,' he invited. 'I'm expecting Lee back any time soon.'

'OK, coffee would be great.

'*Luck Be My Lady!*' she hummed to herself as they went upstairs to the first floor and then into a cramped living room with a kitchen and a bedroom leading off it. Luck be my lady – a gambling song for a gambling girl. This was exactly what she'd meant when she'd told Sinead that something useful would turn up.

Looking around the room while Wim made the coffee, Marina took in a clutter of student stuff like books, papers and a laptop, plus man mess such as odd socks trailed across the carpet, a wet towel draped over a radiator and a pile of unwashed plates on a low table. In one corner she spotted Wim's sleeping arrangements in the shape of a scrunched up sleeping bag.

'So what's a lovely girl like you doing in a dump like this?' Wim asked, returning with two instant coffees, black, no sugar.

'I came for some tickets,' she said truthfully. 'How about you?'

'Me? Oh I'm just passing through.'

'So you're not here for long? Where are you moving on to?'

'Maybe Barcelona. Maybe back to Paris for Christmas.'

*Interesting!* 'What do you do?'

'I'm a postgraduate in film studies, officially attached to NYU – University of New York. But my parents live in Paris now.'

'I'd like to travel,' Marina sighed. 'New York is a place I've always wanted to see – the Empire State Building, the Statue of Liberty!' *So now he's an academic*, she thought. *Maybe he knows that juggling coloured plastic balls wouldn't impress a girl like me!*

She took a sip of the scalding liquid.

'I need this coffee,' Wim confessed. 'I was out late last night.'

'So, no ties?' Taking up the thread of him drifting on from city to city, Marina smiled at him over the rim of her cup.

'Absolutely no ties!' he announced. 'How about you? Do you have a boyfriend? 'Course you do. Stupid question!'

'About those tickets,' she simpered, pretending to be put off her stride by his chauvinist flattery and looking helplessly around the room.

'Maybe they're in Lee's bedroom.' Wim stood up and showed her the way. 'What colour are they?'

'Blue.' She felt Wim brush against her as they turned and knew that it was no accident.

'Sorry,' he said in a way that meant he wasn't. Then he waited for her reaction.

When she didn't instantly move out of his space, he went for it big time. 'You have lovely eyes, they're beautiful.'

Marina raised her eyebrows and stared him straight in the eye. Did he really think she would fall for this crap in this shit-heap of a room with all Lee's dirty laundry scattered on the bed? OK, so he was striking looking and maybe he was used to women throwing themselves at him. But this was way OTT. She steeled herself to stay where she was.

'I would like to kiss you,' Wim whispered, moving in close.

Marina ducked under his approaching arms and skedaddled into the living room. 'I bet you would, mister!' she flung back at him. 'But never in a million years would I want to kiss a smarmy scumbag like you!'

# EIGHT

'Do you think this is how a hangman feels on the day of an execution?' Marina stood at the bay window of Number 13, gazing down the narrow front path.

'Don't be so morbid,' Sinead muttered. 'It's bad enough already.'

'Yeah, snuffing out Frankie's romance before it even gets started,' Marina went on dramatically. 'I hate this, I really do!'

'When did she leave college?'

'About half an hour ago. I texted her to say we needed to talk to her. She said she was on her way.'

Marina and Sinead pictured Frankie on the bus, travelling through the Christmas chaos of

shoppers and bright lights, totally oblivious to what was to come.

'Are we *sure* we want to do this?' Marina turned to Sinead. She wished now she hadn't led Wim on the way she had and got the lousy evidence they needed.

Sinead nodded. 'Sometimes being a good friend is tough,' she insisted.

Upstairs, the music system in Sinead's room played a track about lost love and broken hearts.

'Turn that off.' Marina sighed.

When Sinead came down again, Frankie was turning her key in the front door.

'Hey!' Frankie breezed. 'God, that traffic was a pain! There was an accident outside M & S, cars were jammed in every direction.'

'Hi, Frankie,' Marina said, in her executioner's voice.

'Hi. What's up?'

'Nothing. Well, something.' Marina looked towards Sinead for help.

Taking off her jacket and heading for the kitchen to turn on the kettle, Frankie shrugged. 'Have you sold many tickets for Friday night?'

she asked Marina. 'It's gonna be a good gig. I'm looking forward to it.'

'Frankie, listen . . .' Marina began, then lapsed into silence.

Sinead picked up the loose ball and ran with it. 'We need to talk to you.'

'What about? What did I do wrong? Oh yeah, I forgot the washing-up this morning. Sorry, I know it was my turn, but I had to get that portfolio to the agency, so I was in a big rush.'

'No, it's not that.' Now that it came to it, Sinead was suddenly having doubts. She sighed and turned away.

'What then?' Frankie racked her brains. 'Is it because I got Travis to do the photos? Would you rather I hadn't involved him?'

Sinead shook her head. 'No way. You and Travis are still good mates. I wouldn't expect you to ditch him just because I did.' She looked at Frankie's big, dark, questioning eyes. 'This is about Wim,' she said quietly.

Frankie blinked and looked away.

'There's something you ought to know,' Marina broke in. She concentrated her gaze on the advent calendar hanging on the kitchen

wall just to the left of Frankie. A few nights ago, the three of them had ripped open all twenty-five tiny doors in a joint bout of rampant chocoholism. 'He's dating other women,' she blurted out.

Frankie ducked her chin in towards her chest, as if a boxer had thrown a punch, but she didn't say anything.

'We saw him,' Sinead explained. 'At least, *I* saw him – twice!'

'And I went to Lee's place and checked it out. He came on to me,' Marina added.

'No way!' Frankie tipped her undrunk coffee down the sink. She ran the tap hard. 'He's always texting me, saying he misses me. You must have made a mistake.'

'No, Frankie. OK, so if I'd seen him with another woman once, maybe I could have been wrong. But not twice.' In spite of her own conviction, Sinead could feel the situation sliding out of control.

'And he did try to kiss me,' Marina confirmed uncomfortably.

This was the exact point at which Frankie felt herself explode. 'What did you do to make

him?' she accused. 'Did you do all that sexy stuff you're so good at? You did! You led him on!'

'Only to prove a point,' Marina protested. 'And it didn't take much, I can tell you. He was all over me like a rash.'

'And you, Sinead!' Frankie spun round. 'You're just trying to wreck me and Wim because of you and Travis. Because you're miserable and bitter, you can't bear anyone else to be happy!'

'That's not true,' Sinead gasped. 'We just wanted to warn you about what you were getting yourself into.'

'I *know* what I'm getting myself into, thank you very much! And from where I'm standing it looks pretty darned good. Look, for the first time I've found myself a guy I actually like. No, more than like. I fancy the pants off him, actually. And guess what – he fancies me back!'

*Big deal – Wim van Bulow fancies anything with breasts!* Marina said to herself.

Sinead's fragile confidence was crumbling by the second. She backed out of the kitchen into the hallway.

'I thought you were my friends!' Frankie stormed.

'We *are*,' Marina insisted. 'Honestly, Frankie, as well as the other women he's currently seeing, he's actually been lying to you, telling you he was a juggler and stuff.'

'He is. I've seen him rehearsing!'

'He told me he was a postgraduate student, that he's just passing through. "Absolutely no ties" is what he said.'

'He *was* a student, but now he's taking a break.' The more they went on, the more Frankie refused to believe them. Anger kept flaring up and frazzling her brain. 'Yeah, I thought you were my friends,' she repeated bitterly.

'Oh, God!' Sinead groaned. They'd lost it, for sure.

Marina didn't give up so easily. 'Frankie, listen,' she said, reaching out a hand to touch Frankie's arm.

'Leave me alone!'

'Please! What would you have done if it had been the other way around? If you'd found out that Rob was cheating on me, or Travis was two-timing Sinead?'

'Ha!'

Frankie's angry exclamation reminded Marina of the time, right at the beginning of term, when Frankie had confessed to Marina that she and Travis had 'accidentally' snogged. Then, it had been Marina who had stopped Frankie from telling Sinead. ('OK, so it might ease your guilt,' Marina had said at the time, 'but no way will it improve things for Sinead!')

'Leave me out of it,' Sinead told them from the dark hallway. 'Travis and I are history.'

'You really are a bitch,' Frankie said, putting her face full into Marina's space. 'I can't believe you actually tried it on with Wim.'

'I didn't try it on. *He* did.'

'You set him up. It's called entrapment, in case you didn't know.'

'For your own good,' Marina insisted, backing away, knowing, like Sinead, that they'd lost the argument. How had that happened? How had their best intentions come so unstuck?

'How come you two are suddenly the experts on what's good for me? Do you see me as some little kid – like I'm not capable of making up my own mind about a guy?' Frankie flatly

condemned what they had done. There was no excuse for wrecking her hopes, just pig-headed jealousy. Anyway, she wasn't going to stick around and listen to it any more.

'Where are you going?' Sinead asked, as Frankie pushed past her.

'Out!'

'But you only just got in.'

'Yeah, well I'm off to see Travis!' Frankie retorted, kicking Sinead where she knew it would hurt. 'At least I know I can talk to him and he won't try to bring me down!'

It was midweek and Travis had dug himself into a hole too deep to climb out of.

'Man, you look rough,' Rob had told him fleetingly, between a phone call to Bad Mouth and a trip to the curry house for a takeaway.

Travis had stayed home all day Tuesday and Wednesday. He hadn't slept or eaten, nor even touched his beloved camera since the Monday shoot with Frankie. *What's happening to me?* he asked himself, when a glance in the mirror showed stubble and sunken eyes. But it wasn't a hard question to answer. *What an idiot!* he told

his reflection. *Why couldn't you be happy with what you had with Sinead? You're not going to find it again in a hurry, that's for sure.*

He was saved from his self-pity by a loud knock at the door. Frankie was standing on the doorstep.

'God, you look rough!' she declared, stamping past him and sitting down hard on the bottom step of the narrow staircase.

'Thanks.'

'Jesus, Travis, I'm so friggin' angry!'

He took note of the flushed cheeks and the spark in her eyes. 'Light the blue touchpaper and stand well back!'

'I'm not joking. It's Marina and Sinead. You should hear what they just said!'

*Bang!* The explosion of Frankie's anger lit up the corners of Travis's darkened brain. 'Sinead?'

'Yeah, your ex-girlfriend and my ex-best mate!'

Travis frowned. 'Did you three have a fight?'

'Big style. I won't go into the painful details, apart from that she and Marina just bad-mouthed Wim and expected me to say thank you!'

'Ah!' Travis said, not surprised and managing to squeeze himself onto the step beside her.

'Yeah, well I'm never gonna speak to either of them ever again!' Frankie declared. 'They've been sitting there, cooking this up between them, trying to interfere in my life, giving me advice when nobody even asked them—'

'Hey, hold it.' Travis tried to interrupt. 'Have you thought this through?'

'What?'

'This stuff about never speaking to them again? I mean, you live in the same house, right?'

'Not for much longer,' Frankie vowed. 'I'm going to look for a new place and move out over Christmas. No way am I putting up with that garbage!'

'Wait,' he said again. 'What did Sinead *say* exactly?'

'I don't want to repeat it.' Frankie's throat was tightening, she could feel tears beginning to well up.

'But you, Marina and Sinead can't just split up like that. You're the Gucci girls, remember!'

Travis struggled to lighten things up. 'The Armani angels.'

'Not any more,' Frankie declared. She got a text from Wim and read it. R   u   b u s y . Meet me at 8 at Ohouse

C  u  there, she replied.

'I'm out of here,' she told Travis, springing up from the step. 'If you ask me, you're well out of your relationship with Sinead.'

*I didn't ask,* Travis said to himself.

'And as for Marina Kent, you'd better warn Rob to watch out. I personally wouldn't trust her as far as I could throw her!'

**Major crisis!** Marina blogged. **Frankie just took something the wrong way and now our world is falling apart.**

**No details, but this is to do with men and it's SERIOUS!**

**Things were said, insults were thrown that can never be taken back. It bloody hurts, I can tell you.**

**So if anyone out there has advice about housemates arguing over guys, please get in touch.**

**Otherwise, life here at Number 13 is gonna be miserable, what with the upcoming Friday gig, then Christmas and all . . .**

Sinead went to bed early and lay there feeling numb. Confrontation was something she'd never been able to handle, and she desperately wished she'd listened to Marina's early advice and just dropped the whole Wim thing. Now, all she had in her mind was a memory of Frankie's face changing from happy-go-lucky to wild anger, her chin tucking in, her eyes narrowing. *Why did we do it?* she groaned. *Frankie would've found out for herself soon enough!* Well, she'd never been any good at judging these things, always taking them too seriously, always too intense.

'Darling, it's not your problem!' She imagined Daniella's voice on the phone, trying to put her right before she jumped in with two left feet. 'Frankie has to work these things out for herself.'

Not that her mother was ever around when Sinead needed advice, even when she was little. Daniella had always farmed her out to nannies

and relatives while she jetted off here and there.

*Get a grip!* Sinead told herself from between the cold sheets. *Now is not the time to play the lonely little rich kid. Concentrate on what just happened with Frankie, and work out how to make it better.*

But nothing occurred to her as she stared up at the ceiling.

Wim arrived twenty minutes late in the faded, seedy coffee bar at the Roundhouse. He was dressed in a black T-shirt that showed off his muscly arms, and great, loose-fitting Levis. There was a couple of days' stubble on his chin and a wide smile on his lips.

'Hey!' he said to Frankie, putting his arms around her.

And oh, those lips, that kiss, the blurring of his blue-grey eyes as he came close.

Very early next morning, before either Marina or Sinead were out of bed, Frankie picked up an urgent message on her phone.

`Pls call Jessica West`

'... Great, Frankie, thanks for ringing.' The

Bed-Head receptionist had undergone a personality transplant. Today she was bright and eager, briskly efficient. 'I'll put you through to Jessica. Please hold.'

There was a silence and then a few clicks. 'Is that Frankie McLerran?'

'Hi, it's me.' She felt her pulse race, but there was no time to really register it before Jessica went on.

'Listen, love, a job has just come up and I think it might be one you could do.'

'Cool. What is it?'

'It's very last minute. A big-name model called half an hour ago to pull out of an assignment in Gateshead.'

'Where's that?'

'Near Newcastle. The location is at a new concert hall by the river. Everything is set up for the shoot, and now they're desperate for a model. The trouble is, almost everyone on our books is busy, so I put your name forward and e-mailed them your picture.'

'Great,' Frankie said, knowing how dumb that sounded. It was the only word she could frame as her head whirled.

'Can you get yourself a train ticket and be up there by two o'clock?'

That probably gave her about half an hour to get on a train. 'I'll try,' she promised.

'It's a great chance for you, love. No need to pack anything, just get yourself there and take it as it comes. Here are the details . . .'

Dull green fields flashed by as Frankie sat on the inter-city to Newcastle. Pylons strode across the countryside. In the distance, wide cooling towers belched out steam.

*I have a job!* Frankie repeated to herself, to the rhythm of the wheels clicking over the steel rails. *I have a job – I have a man – I have a job – I have a man.*

*Clickety-click,* the train sped on.

Outside, a rainbow. Inside, a trolley service bringing coffee and tea. Frankie's hands shook as she paid for her drink. *I have a man – I have a job, whoo-hoo!*

# NINE

In life-drawing classes, Sinead always found she could switch off her worries and give total focus to her work. She would concentrate on the charcoal marks on the paper – the light, feathery strokes merging into heavy blocks of shade which she would create with the flat end of her stick. Then she would erase areas and work again, constantly glancing at the model, occasionally standing back to judge the effects she had created.

'Nice work,' Jack told her at the end of the session. 'You can feel the weight of the body in that drawing.'

'Your poor guy looks like a corpse!' Marina pointed out, as the model – a skinny guy with

long hair and a beard – got up from his pose stretched out on a blanket on the floor. 'A dead Christ.'

Sinead sprayed fixative onto her sketch. 'I guess that shows my lousy state of mind.'

'Haven't you and Travis found time to talk yet?' Marina sympathised.

'What's to talk about?'

Together, Marina and Sinead stacked their drawing boards against the wall, rolled up their sketches and left the studio.

'What are we going to do about Frankie?' Marina asked, guiding Sinead towards the coffee bar. 'She came in late last night – did you hear?'

Sinead nodded. 'And this morning she was up before I was.'

'So why didn't she show up for life-drawing?'

'I've no idea. It looks like she's avoiding us.'

'Nightmare!' Marina muttered. Here was Sinead, going about as if Travis didn't exist, acting like they'd never been the most loved-up couple in the universe. And now Frankie was blanking the two of them, her best friends. The whole world was falling apart. 'I hope Frankie

doesn't do something stupid,' she went on.

'Like what?' Sinead's mind was blank, so she wasn't on her guard when the door to the coffee bar swung open and Travis walked in.

'Like, go with Wim just to prove us wrong.' Marina could easily picture this happening, and then, when Wim dumped Frankie, she and Sinead would feel even more guilty than they already did.

'"Go with", as in "doing it"?' After the shock of seeing Travis, Sinead shrank back against the wall. Maybe he wouldn't look her way.

Marina nodded. 'I have a theory about that too. I don't think Frankie ever did – y'know.'

Sinead frowned. 'You mean, she's still a virgin?'

'Yeah. Is it mean to be discussing her like this? She's never actually said she is. It's just a feeling I get.'

'It's not mean,' Sinead decided. Out of the corner of her eye, she could see Travis ordering coffee at the counter. 'I agree. Frankie's kind of innocent, and that means Wim is exactly the sort of guy she shouldn't be going out with. For a start, he's a heck of a lot older.'

Marina took a deep breath. 'It's like feeding her to the wolves.'

'But no way will she listen to us after last night.' Sinead saw that Travis had turned. He was looking straight at her, hesitating. 'I gotta go!' she said suddenly, grabbing her stuff and rushing for the exit.

Travis brought his coffee over to Marina's table. He sat down heavily. 'Do I have bird flu, or something?'

'Looks like it,' Marina admitted. 'I'd like to say don't worry, she'll soon get over it, whatever it was. But knowing Sinead . . .'

'Yeah,' Travis groaned. Hypersensitive, thin-skinned Sinead.

'Have you seen Frankie anywhere?' Marina asked, to change the subject.

'Yep. No. I mean, she texted me an hour ago.'

'What did she say?'

'She's on a train to Newcastle,' he said absent-mindedly. 'Something about a model-ling job up in Gateshead.'

Marina skipped lunch and went up to the cutting room for some peace and quiet. She still

**113**

hadn't finished the application forms for work experience, and it was bugging her. Up here, no one would interrupt.

*Wro-ong!* she said to herself, as Rob burst through the door.

'Marina, help!' he wailed. 'Emergency. I just got a message from Boz. Their bass guitarist went on a bender. They had to sign him into a clinic to detox. What the hell are we gonna do?'

'Find another guitarist?' Marina suggested logically. But this wasn't good news, only twenty-something hours before the gig. 'Rob, calm down. Can't they bring in a session musician? There must be loads around.'

Rob covered his face with his hand. 'I guess. Just remind me never to do this again, will you?'

'Poor baby,' she soothed, putting her arms around his neck. 'Listen, don't *you* know anyone who could stand in at the last minute?'

'I'm a part-time DJ, not a bloody talent scout!'

Marina thought hard. 'What about Travis?'

'Travis?'

'Yeah, T-R-A . . .'

'OK, OK. Yeah, he does pick up my guitar and

strum it once in a while. I'm not sure how good he is though.'

'It doesn't matter, he's great eye candy. Jeez, what am I thinking!' Marina said, suddenly changing tack. 'Travis plays *your* guitar. It's you who joined a band, for Chrissakes!'

Rob swallowed hard. 'Years ago, when I was still at school.'

'But you were really good, weren't you?' She had total faith in him, holding him by the sleeves of his leather jacket, staring earnestly at him.

'Not bad. But listen, I haven't picked up a guitar and played seriously for months. No, babe, it's a bad idea.'

'So is having to cancel the gig because Bad Mouth mislaid their bass guitarist,' Marina pointed out. 'C'mon, Rob, let's get back to your place so you can start practising!'

# TEN

There was a bleak wintery sunshine glittering on the River Tyne for Frankie's first fashion shoot. The backdrop was a brilliant modern drawbridge that opened like a giant eyelid to let ships pass underneath, plus the funky concert hall – a building with no straight lines, shaped like an armadillo and coated in segments of metal which reflected the light from the northern sky.

They dressed her in layers of tulle and ruffles, in dresses that left her shoulders bare and exposed her long, elegant legs.

'Very American prom,' the stylist said, choosing matching clutch bags and high sandals.

There Frankie was, posing on the bridge in a temperature below freezing, trying not to shiver,

convinced that she was turning blue with cold.

'Love the cupcake colours of that frock!' the make-up girl enthused. 'I think she needs more blusher.'

*I need a fur coat and thermal knickers!* Frankie said to herself. Whoever thought that modelling was glamorous?

But it was cool, being frouffed-up and back-combed, having a whole team of people working on you, making jokes, getting sprayed and lacquered before you went out and flirted with the camera lens.

'Good job,' the fashion editor complimented her afterwards.

Draped in her own tangerine duffel coat, Frankie hung around for the cheque.

'We pay your agent,' the editor explained kindly. 'She takes her cut and sends the rest to you.'

'Ah!'

'I can lend you your train fare home if you're short of cash.'

'No, it's fine, thanks.' Frankie shot off to the station, her cheeks burning.

'She's a little sweetie,' the editor said to the

photographer, watching Frankie beat a hasty retreat as they packed up their gear.

'Yep, she'll be eaten alive,' he predicted. 'They'll chew her up and spit her out before New Year – unless she's tougher than she looks.'

`Boz found new guitar player,` Rob texted Marina.

`Thnk heavens 4 tht,` she replied.

'Crisis averted.' She reported the latest news to Sinead at breakfast on Friday. 'Now poor Travis won't have to stand in.'

Sinead winced over her cup of black coffee.

'Sorry, I forgot I'm not allowed to mention his name.'

'Mention away,' Sinead muttered. 'It doesn't bother me.'

'No? You only run a mile when he comes into the room. You're moping around the place as if they'd just announced World War Three.'

Sinead sighed. 'OK, so splitting with him was probably the biggest mistake of my entire life.'

'It doesn't have to be. Talking to him would be another option. Getting back together, having a hunky-dory Christmas, starting over . . .'

'It's not that simple.'

'Why not? Rob says Travis is in bits over this too. If you're both so miserable, why not try to put it right?'

'Because!' Sinead wished there was a magic wand that could cancel out Travis's jealousy, her insecurities. But every time she thought of him, she remembered the bitching about her mother, the moods and sulks. 'I can't take the pressure right now.'

Marina shook her head. 'Your problem is, you want "Once upon a time" and "Happy ever after", but you've got to realise you're never going to find it.'

'But that's what I thought Travis and I had – at first.'

'Sinead, that's what everyone has – a fairytale romance for the first week if they're lucky. Red roses, moonlight, chocolate – fantastic sex! After that, it's all downhill!'

Even Sinead had to smile. 'Anyway, did you fill in your form for work experience yet?'

'Almost.'

'I take that as a negative. Well listen, Daniella says she could get all three of us a placement in

Paris if we wanted. She knows the right people in all the fashion houses in capital cities all over Europe – I bet she could do it!'

Marina's eyes lit up. 'Did you hear that, Frankie? How do you fancy Paris in springtime?'

Frankie had come into the kitchen with a blank expression. 'I'll find my own work experience, thanks,' she muttered.

'How did it go in Gateshead yesterday?' Sinead persisted, in spite of the knock-back. 'Travis told Marina that the agency had found you a job. How amazing is that! Was it totally cool?'

'It was OK.' Frankie refused to be drawn, though she was longing to tell someone about the amount of work that went into a shoot, the hanging around waiting for the right light, the frayed nerves, the gawping passers-by, the way she'd wished the ground would open up and swallow her when she'd mentioned the cheque. Not sharing with Marina and Sinead was killing her. But she wasn't ready to forgive them – no way!

'Better than serving behind a bar,' Marina said glumly.

'Oh, by the way,' Frankie said coldly, having

spent a sleepless night thinking about the situation at Number 13. 'I'm planning to go to the housing office today.'

'Frankie, don't!' Marina wailed, falling back on her usual line. 'Let's discuss this.'

Sinead frowned but said nothing.

'What's to discuss?' Frankie went on, her mind set hard as concrete on the subject. 'I'm going out with Wim, period. He's my guy. You made it totally plain that neither of you can stand the sight of him. What else can I do except ask the housing officer to find me a new place to live?'

'I need you, mate,' Rob told Travis at the main entrance to the college. He'd given his house-mate a lift in on the bike, only to hear that Travis wasn't sticking around for the gig that evening.

'Need – schmeed. I got stuff to do tonight.'

'What stuff?' Unzipping his jacket, Rob strode ahead across the entrance hall. 'Hey,' he said to the tall Dutch guy – Wim – whose guts Marina hated for some reason. 'C'mon, Trav, we need bouncers on the door. I put your name down.'

'Why's he hanging around here?'Travis muttered, with a glance over his shoulder at Mister Unpopular.

'Dunno. Listen, if you work on the door, you get to see the gig for free.'

'OK, maybe,'Travis half relented. After all, he couldn't shut himself away like a monk, just because he was afraid of bumping into Sinead.

'Nice one. Bad Mouth are gonna be the next big thing in indie music, you'll see.'

'OK, I give in.'Travis split off at the corner of the hall and turned left towards the lifts. 'What time?'

'Seven, in the union bar. See you there.'

'This is so weird without Frankie,' Sinead said. Marina had arrived in her room with an armful of dresses, tops and trousers. It was five o'clock. They had two hours to get ready for the gig. So far there was no sign of their housemate.

'I know, we're a trio,' Marina agreed. 'Glamming up without Frankie feels like we're missing a limb or something.'

Sinead towelled her short blonde hair and

ran a brush through it. Then she tossed her head upside down and turned on the drier. 'I wonder if Frankie went to the housing office like she said.'

'I don't know, but Rob says he saw Wim in college this morning. I expect he was there to meet her.' Marina picked a pearly pink jersey dress from the pile. 'This doesn't look much, but it's slinky when it's on. What do you think?'

'Hold it up, let me see.' The dress had a halter neck and a hemline that split dramatically at the front. 'Try it on,' Sinead suggested. 'With the silver strappy platforms.'

Marina slithered into it and paraded across the room.

'Very Versace,' Sinead declared. 'I like it.'

'D'you like it enough?' Turning sideways, Marina studied herself in Sinead's full-length mirror.

'Yes, I love it.' Sinead styled her hair, sweeping a section forward across her forehead in a bold downwards curve, then fluffing out the very top into a halo of feathery spikes. 'I've made a top and trousers, but I haven't worn them yet.'

'Show me.'

Sinead opened her wardrobe and took out a skimpy silver satin top with a diamante-encrusted halter-strap. The trousers were pleated into a waistband and fell loose and wide in the leg.

'Yeah, you could get away with that.' Marina admired the hand-sewn detail. 'It's gorgeous,' she sighed.

'With these?' Sinead held up her Tiffany Jazz earrings, an eighteenth birthday present from her mother.

'I could kill you!' Marina sighed.

'Are they too much?' Sinead was worried that the earrings were a glamorous step too far.

'No, perfect, honestly.' Marina almost turned to Frankie for back-up, but then remembered in time. She went for her hair straighteners instead.

'I'm really nervous about tonight,' Sinead called. 'I guess Travis will be there, right?'

'Yeah. I'm having kittens too. Rob's put so much into this. I want it to work out for him.'

'It'll work,' Sinead assured her, fixing her earrings and glossing her lips.

They put the finishing touches to their hair and make-up, gave each other the thumbs-up and hit the road.

Frankie waited until Marina and Sinead had left the house. If the gig started at eight-thirty, they would need to arrive early to help out with tickets. That meant them leaving by seven.

At seven-thirty she turned her key in the lock.

The place was empty, thank God. It smelled of perfume and hairspray; there were dresses hanging over the banister and shoes scattered along the landing. Frankie ran the obstacle course, went into her room and sat down heavily on the bed.

What a day! The woman in the housing office had spent ages searching for addresses and come up with only two possibilities.

'Bad time of year,' she'd told Frankie. 'Landlords aren't putting places on the market before Christmas, and besides, it's hard to find accommodation for one person, unless you want to share.'

Frankie had told her no to sharing with

strangers. 'I like living by myself,' she'd insisted, although she'd never tried it.

'Well, there's this attic bedsit in a terraced house on Station Parade, and a basement in Wellington Street.'

Coming out of the office, Frankie had picked up a message from Wim. `Where r u`

`On campus,` she replied.

`Me 2`

`Meet at clock tower`

`C u in 5`

A delighted Frankie had allowed a coffee latte to turn into a long lunch and before she knew it she found she had skipped yet another of Claudia's classes.

Frankie had described the tensions at Number 13 and her mission to find a bedsit, but without bringing Wim's name into it. Then Wim had kept her entertained with stories of his youth.

'I was a dog walker in New York when I was thirteen,' he'd told her. 'Ten dollars per hour, and I would walk at least three dogs at a time. Afghans, St Bernards, Great Danes. I would teach them to do tricks with balls and sticks in

Central Park – that's how my love affair with the circus began. Y'know, I even walked famous people's pooches.'

'For instance?'

'I once walked a Kennedy poodle, and a German shepherd belonging to the Mayor of New York.'

'Any film stars' dogs?'

'Yes, but I was sworn to canine secrecy. It was part of the deal not to tell anyone where Sharon Stone's Dalmatian or Harrison Ford's shih-tzu hung out!'

'You've lived an amazing life,' Frankie had sighed, thinking of her parents' pebble-dashed semi and Nipper, their motley rescue mutt.

Then Wim had looked at his watch and dashed off, with the promise that he would try to make it to the gig by midnight, but that he might be a bit late. A hasty kiss later, he was gone.

So Frankie had followed up the two housing office addresses. The attic had overlooked the station. Announcements blared, trains thundered by and shook the Victorian house. The basement bedsit had been squalid beyond

belief, the stink of cats pervading the entire place.

And now she was home, amidst the girly clutter, but minus the giggles. She had to decide what to wear, how to do her hair, which jewellery to choose, and she had to do it solo.

*I have to get this right,* she told herself. *It's our first real date and I want to knock Wim's socks off!*

Six outfits later, she'd reached rock bottom.

*Too summery,* she decided about her knee-length taupe skirt with bold cream flowers and leaves screen-printed in a border round the hem.

*Too much flesh,* she said about a ruched, cream silk jacket that fastened with a single button and exposed both cleavage and belly button.

*God no, what was I thinking!* The red snakeskin bustier with the low-slung hipster jeans was cast aside without a second glance.

*Better!* For a while she studied the Stella McCartney style, long, pale blue cotton dress with loose layers to bodice and skirt. But again, not winter gear.

The hippie-trippy halter neck and the op-art jumpsuit both went the same way as the others.

Then at last Frankie found a look she was happy with. It was the bronze-coloured, pleated silk skirt that Marina liked, teamed with a scoop-necked black top trimmed with ethnic rosettes crocheted in browns, orange and cream.

*Hair loose,* she decided. *Shoes – high black platforms.* The good thing (*one* of the zillion good things!) about Wim was that he was so tall she didn't have to worry about the height of her heels.

Taking stock of the outfit she'd chosen, Frankie found a pale foundation for her face, then accentuated her eyes with lots of browny-gold shadow and liner. She left her full lips pale for effect.

*Enough already!* she finally said. *This is it, if I look in the mirror for another nanosecond, I'll implode!*

Then she too was out of the house. It was nine-thirty. Her heart hammered against her ribs, but there was no one to share her panic with as she hailed a number 11 bus and headed for the students' union.

# ELEVEN

*'Word gets around . . .*
  *We're over*
  *All around town*
  *We're over . . .'*

Sinead danced with Marina to the music. The lyrics of Bad Mouth's third number whirled inside her head.

  *'They thought we were for ever*
  *That we would never . . .*
  *Part*
  *But now we're over . . .!'*

Boz had an amazing, soaring, soulful voice. He'd said in his intro that the song was for

anyone who had ever lost love.

*That's me!* Sinead thought, dancing herself into a daze.

*That's me!* Travis thought, standing by the door, watching Sinead from a safe distance.

Rob exchanged a brief high five with Travis as he passed. The place was packed, it was a sell-out, everything had come good.

'We're over!' Boz sang. Drums thudded out a failing heartbeat rhythm, the keyboard player let the notes fade.

The crowd danced shoulder to shoulder; the girls glittered, the boys played it cool. At the end of the song, people stood and cheered.

'These guys are wicked,' Lee and his mates told Rob. 'Can we buy a CD?'

Rob shrugged. 'Let me ask them if they brought any when they finish the set.'

'We want to buy you a drink, mate. What are you having?'

Marina caught sight of Rob heading for the bar with a gang of blokes, abandoned Sinead, who carried on dancing solo, and went to intercept him. 'Dance!' Marina insisted, pulling him onto the dance floor.

'Drink!' he pleaded. 'I'm gagging.'

'Dance!' She swung her hips and tossed back her blonde hair. A dozen gawping guys made room for the pink sex-goddess.

So Rob danced.

Left to herself, Sinead drifted towards the stage, where she had a great view of Boz the singer. He had the cutest face, with big brown eyes and slightly sticky-out ears. His baggy white sweatshirt made him look little-boy skinny. The band had moved on to a new song and she had to listen hard to pick up the lyrics blaring out from the nearby speakers.

*'I once loved a girl*
*A girl with an open heart . . .'*

The number was upbeat, a great one to dance to.

*'Still inside my head*
*Tho' we are far apart*
*Blonde girl, I love you . . .*
*You're beautiful*
*My blonde girl!'*

Sinead swayed and danced in her silver outfit. The lights flashed on her, making her sparkle all over.

'Blonde girl, I love you . . . My blonde girl!' Boz sang to the crowd.

He caught Sinead's eye. For a moment she thought he was singing only to her.

Frankie walked into a gig that was already buzzing. There was no band onstage – only Rob dee-jaying, with Marina at his side.

'Hey, Frankie,' one of Lee's mates greeted her. 'You just missed a great set.'

She forced a smile and took a good look around. In the end she made for a group of girls from her year and let herself be swallowed up, well out of sight of Marina and Sinead.

'You should have been here earlier,' Katrine told her, checking out Frankie's shiny mini-pleats and trendy crocheted trim, and jealously scoring her a nine out of ten. 'You missed the band.'

'They'll do another set,' Daisy promised. 'Get an eyeful of the drummer, but keep your mitts off him. He's mine, OK!'

'You wish!' Frankie grinned.

'No, the singer!' Katrine insisted, pointing Boz out as he stood at the bar with Sinead. 'He's so cute! Isn't he cute, Frankie? Take a look!'

'Richie on keyboards writes the music and I write the lyrics,' Boz was telling Sinead at half-time. He'd come offstage, made a bee-line for her and invited her to the bar for a drink.

For five minutes she'd been too stunned to say anything. 'How long has the band been together?' she asked now.

'Eight months. But we only started gigging in October, in Dublin.'

'I was born in Dublin,' Sinead told him eagerly.

'Cool place. Temple Bar, O'Connell Street, that building with the bullet holes in the walls.'

'The General Post Office.'

'That's the one. And I like the Irish. You can have a good craic with them.'

Sinead found they were getting on really well. Boz was plying her with her favourite Bacardi Breezers, paying her lots of attention. Perhaps he really *had* picked her out and sung

'Blonde Girl' just for her. 'I miss home some-times,' she confessed.

'Is there someone special back in the Land of Guinness?'

She shook her head. 'No. I'm not with anyone.'

Boz shook his head and tutted. 'What are they thinking, letting a girl like you out on the town?'

'And who would "they" be?' she demanded. 'A girl can choose to be single, can't she?'

'It's a waste, is all I'm saying.' Boz drank up and nodded at Richie, who was calling him back onstage for Bad Mouth's second set. 'I'll see you after?' he asked with a hint of cockiness, as if life these days was one long succession of groupies.

'Maybe,' Sinead told him. Yeah, he was cute, and yeah, he was talented, but big-headed didn't do it for her.

Wim was late as usual. Twelve o'clock came and went, Frankie looked at her watch and drank too much.

'Hey, Frankie, you look great,' a voice said above the crash of drums and the whine of gui-tars.

She turned and came face to face with a nervously smiling Sinead.

The words 'two-faced bitch' came flying into Frankie's head. 'You can cut out the nicey-nicey stuff,' she retorted. 'I don't want to talk to you, remember?'

'Frankie, listen.' After a few Bacardis, Sinead threw caution to the wind. 'Why can't we go back to how it was? I know I was out of order, laying into Wim like that, but it wasn't deliberate. Marina and I – we didn't set out to upset you.'

'You mean, you did all that without even trying?' Frankie's voice was high with sarcasm. 'Wow, I'd hate to hear you when you really want to tear a person to pieces!'

Sinead swallowed hard. 'I guess we didn't think. But we're genuinely sorry.'

'Sorry isn't good enough,' Frankie told her, unable to hide another glance at her watch. Twelve-thirty and still no sign of Wim. Her stomach churned, she felt nauseous.

*'There's no mistake*
*I feel the rain*

*On my face*
*I feel the pain*
*Winter's in the air*
*. . .Without you.'*

'Don't get hurt, Frankie,' Sinead pleaded.

*'Without you-o-o!'*

Frankie closed her eyes, turned and walked away.

Sinead turned in the opposite direction. She bumped smack into Travis.

'Is there anything I can do?' he asked.

Sinead gasped. Here was Travis – in his favourite faded jacket, his torn jeans, looking pale, his eyes piercing her.

'I just saw what happened with Frankie,' he murmured.

*'There's no mistake*
*I see the tears*
*On your cheek*
*I see the fears*
*Winter's in the air . . .'*

'You can't do anything,' she told him. Then, 'Yes, actually, you can.'

Travis wanted to hold Sinead, to hold her like he used to. He wanted to wake up with her tomorrow morning and see the sun on her face.

'You can watch out for Frankie,' she said. 'She trusts you, Travis. Keep an eye on her and don't let anything horrible happen.'

'You want me to wave a magic wand?' he asked with a despairing shrug.

But Sinead had gone. The song had finished. It was well past midnight and the princess had left him nothing, not even a slipper.

'At last!' Wim said to Frankie before she could complain. 'I made it!'

There he was – so handsome, so cool – pushing his way through the crowd. And here he was, kissing her, offering no explanations, only a drink, then smiling and asking her if the gig had been good and telling her he was sorry he'd missed most of it, but his show had gone on late, and she looked sexy and how could he be expected to keep his hands off her if she went around looking like that?

Frankie's cold heart melted, the knots in her stomach untwisted. He was here now, and Bad Mouth was still playing. 'Let's dance!'

But, 'I'm tired,' he said. 'Come and talk.'

He took her outside, into the yard with the fountain, where she'd first seen him in the snow. 'You're not angry with me?'

Frankie shook her head. 'No, it's cool. I had a good time, actually.' *Liar, liar! You nearly died in there!*

'I had a crap time,' Wim sighed. 'We heard today that the circus has to finish.'

'How do you mean?' There were stars in the sky. It was bitterly cold.

'Finish. There's no money. We have to break up.'

'Oh, that's awful!' Frankie gasped. He gave the news with a throwaway shrug, but it meant no more acrobats, no more trapeze artists swinging and catching, or jugglers throwing flaming torches into the air. Perhaps no more Wim. 'What will you do?'

'It's too soon to decide. But let's talk about something else, huh? Did you find a place to stay?'

'Let's talk about something else!' she echoed.

'Let's not talk.' Wim kissed her again. 'Let's walk.'

Arm in arm they went down the wide white steps onto the street, under the lamps and the Christmas lights.

Lee, Travis and Rob stayed behind to help the roadie dismantle the band's sound equipment.

'Did you see Lee's biceps and six-pack?' Marina joked with Sinead. 'Frankie doesn't know what she's missing!'

'She's not missing anything. She went off with Wim,' Sinead reported glumly. The hall that minutes earlier had exploded with cheers and applause for the band had quickly fallen silent. There was litter on the floor, a few drunks and snogging couples leaning against walls. 'Are we getting a taxi back, or what?'

'Wait here while I find out what Rob's doing.'

'All alone?' Boz asked, sneaking up on Sinead from behind.

'Good gig,' she smiled uneasily.

'Still inside my head . . . Blonde girl!' Boz sang in a low voice.

She felt his arm creep around her waist.

Travis dropped the end of the speaker he and Rob were carrying.

'Oof!' Rob grunted.

'You're pushing your luck, you know that?' Sinead told Boz. But hey, what the hell! He was a singer in a band, he wrote great love songs. Besides, she'd lost count of the Bacardis she'd drunk.

'Get a hold of that end,' Rob told Travis. 'Ready, lift!'

Boz leaned in for a serious snog. He was well rehearsed.

Sinead felt the top of her head lift and her brain take its leave. Boz had her pressed against the wall, her arms around his neck. The kiss was everything.

This time Travis staggered with Rob out of the hall. He dumped the speaker in the back of the van, then bent double, as if someone had punched him in the stomach. Rob left him there and went back for cable and mikes.

Eventually even Boz's tongue had to take a break. He ducked his head to one side and began to peck gently at Sinead's neck. She

stroked the back of his head.

A drunk guy wandered into her blurred vision, then Marina.

'Taxi!' Marina mouthed, pointing at the exit.

'My taxi's here,' Sinead murmured to Boz.

'No way!' he protested. 'There's space for you in the van.'

'I'm OK,' Sinead told Marina.

All Marina could see was the back of the lead singer's baggy white sweatshirt and loose-fitting Levis, plus glimpses of Sinead's thin arms and feathery blonde head. 'Sure?' she mouthed.

'Sure,' Sinead confirmed, as Boz suddenly grabbed her by the wrist and made for the door.

Outside, the back of the van was open, the speakers were loaded, the yard was empty.

Travis had drifted off into the darkness when he'd heard Sinead and Boz coming. He'd recognised her voice telling Marina that she would be OK, had seen Boz mauling his ex-girlfriend as he'd helped her into the passenger seat.

He had a choice – either grab the gorilla who had his sweaty hands all over Sinead and his tongue shoved down her throat, or go and throw himself into the nearest canal.

'Where's Travis?' Rob asked, as the last of the band members climbed into the back of the van. Boz was in the driver's seat, Sinead leaning drunkenly against him.

'Gone home, I guess,' Marina answered. The tariff on her taxi meter had already hit the ceiling. 'See you there.'

'See you there,' he echoed, putting on his crash hat, sighing, and dumping Travis's helmet back in the luggage locker behind the pillion seat.

# TWELVE

'OK, so where is he?' Rob had looked in Travis's room and found it empty. He came back downstairs to Marina.

'When did you last see him?' she asked.

'After the gig. He was loading stuff into the van with me, then suddenly he wasn't.'

'Poor Travis.' Marina lay flat out on the sofa and kicked off her shoes. 'It must have been torture for him watching Sinead getting off with Boz.'

'Yeah, and I was the one who made him come along. I thought it was time for him to move on.'

'Too soon,' Marina sighed, making room on the sofa for Rob. 'Are you really worried about him?'

'He can take care of himself, I guess.' Rob

pictured how he might feel and what he would do in Travis's shoes. He would feel like shit and he would probably go on to a club and drink himself into a stupor. 'Did I say thanks?' he asked Marina, snuggling up close, grateful that he didn't have Travis's problem to deal with.

'What for?'

'For everything. For helping with the tickets, for making tonight work.'

'That was down to you, Rob. You're Mr Fix-It.'

'It was a good night.'

'A great night.' Wrapping her arms around him, she nuzzled his neck. She felt the weight of his body resting against her, and the warmth, and his special Rob smell.

'I don't believe you,' he murmured.

'What don't you believe?'

'. . . You!' he said in a thick voice. 'Every single bit of you!' He kissed her and folded her into him. And he knew he would never in his whole life, even if he lived till he was eighty, be happier or more into a woman than he was with Marina Kent.

'Come on, it's OK, there's no one home,' Wim

urged on the steps of Lee's house on Nugent Road. 'Look, there are no lights.'

'This doesn't feel good.' Frankie hesitated. She and Wim had walked through the town, out into the dark, narrow streets of student bedsit-land. 'What if Lee comes back?'

'What do you care?'

'I don't. But I don't want to hurt his feelings, that's all.'

'So, let's go to your place,' he suggested.

Frankie shook her head. 'No, we can't do that! Here is better.' This was getting silly, she realised. So what if Lee came home and gave her his hurt look? She would just have to tough it out. Anyway, it was freezing out here.

'It's no big deal – only coffee,' Wim reminded her, opening the door and leading her up the stairs. 'Hey, crazy girl, you're safe with me.'

Frankie followed. The night could have gone better, she realised, but the main thing was that she and Wim had ended up together, in spite of what Marina and Sinead had said about him.

'Black or white?' he asked, wielding a coffee spoon.

'Black.' Frankie looked for a place to sit. She moved newspapers off the futon then perched on the edge.

'Relax,' Wim told her. 'I won't bite. Isn't that what you English say? I won't bite – unless you want me to!'

'Biting is out!' Frankie insisted with a grin. She made room for him beside her. 'But kissing is fine.'

'. . . More than fine,' he said, coming up for air. 'You drive me wild, you know that?'

'Hmm.'

'What does "hmm" mean?'

'It means, "How come? Why me?"'

He leaned back and studied her face. 'You don't know?'

'No, really.'

'Frankie, you have a fantastic body, you must understand. And your face is perfect.'

'Hey!' she protested. 'I'm not digging for fake compliments here.'

'It's not fake. You're exceptional, believe me. But the truly great thing about you is your personality, and the way it shines in your eyes.'

'What *is* my personality?'

'Completely natural. No ego getting in the way. Full of life, full of fun.'

'Hmm,' she repeated doubtfully.

'OK, don't believe me,' Wim laughed. 'But you are what I say, and the fact that you don't know it proves it!'

'Hey, that's way too complicated!' she protested, feeling herself sucked helter-skelter into his charm, arms waving, mouth open and squealing. God, she was helpless, and she was enjoying every second.

But when she felt Wim's hands slide under her top and make contact with her skin, something clicked and she hesitated.

'What's wrong?' he cajoled, covering her face in kisses.

'Nothing.' *God, what if Lee walks in and finds us naked?*

'C'mon, Frankie!'

*What the hell!* She let him unhook her bra. But somehow the mood had changed. His fingers seemed mechanical, she stopped feeling like someone special. 'No, it's too soon,' she whispered. 'Sorry.'

He extricated his long limbs and sat up. 'Hey, no problem,' he said.

'Thanks.' With her hair all over the place, and struggling to put her clothes straight, Frankie felt like a little kid. 'I'm just not ready,' she explained.

'It's OK.' Wim brushed stray hair from her face with his thumb, then matter of factly helped her refasten her bra. 'There's plenty of time,' he said with a yawn.

She stood up unsteadily and reached for her jacket. 'It's late. I'd better go.'

'Shall I call a cab?'

'No, I'll walk. It's not far.'

'I'll walk with you.'

'No need,' Frankie said quickly, with an overwhelming urge to slide away unnoticed. 'You're tired, and I promise you, I don't mind walking by myself.'

Wim yawned again. 'Yeah, it's been a long day.'

She was ready to go, hovering by the door.

'I'll text you,' he promised.

The kiss goodnight was warm and friendly enough.

'See you,' she said.

'Yeah, see you.'

The new and happening Salon was the club that Boz chose to take Sinead to after the gig, and after he'd dropped off the other guys from the band. 'You're up for this, aren't you?' he challenged.

'Wild horses wouldn't stop me,' she replied, darting onto the dance floor and getting straight into the music.

Boz followed her, but so many people recognised him that he was soon hauled off to the bar to sign autographs.

*That's cool!* Sinead thought, dancing on until thirst drove her to join Boz from the Band. She had to elbow her way through layers of women, and when she reached him, she noticed that his eyes were unfocused, his reactions slow. Wondering what he'd taken, she asked the barman for water and offered Boz some from her bottle.

'Thanks,' Boz nodded, as if he had trouble placing Sinead. Then it registered that they must have come along together. 'Drink?' he

asked, handing her his own bottle of Becks.

Sinead shook her head. She was rapidly going off this groupie thing and realising that alone in her own bed was where she most wanted to be.

'Drink!' Boz insisted, shoving the neck of the bottle against her lips. Then he swung the other arm around her neck and dragged her away from the bar. 'You're no fun,' he slurred.

'Likewise,' she muttered, wondering how come singing in a band bestowed a divine right to piss people off.

'Dance, then,' he insisted, staggering between swaying couples. When he grabbed her round the waist, he swayed forward and managed to spill half the contents of his beer bottle down her front.

Sinead stared at her drenched top. 'Here!' she said suddenly to the nearest available girl, shoving Boz at her. 'He's the lead singer with Bad Mouth – very pissed, probably smashed. He's yours if you want him!'

The girl stepped in eagerly. The last Sinead saw of her soulful singer, he was draped over

the willing brunette, leaning against a pillar, oblivious.

*Get a grip!* Frankie told herself furiously. *No way was I having sex on our first date. How cheap would that have seemed!*

But, an inner voice said, *He'll think you're a frigid little no-hoper. He won't ring you. In fact, if I were you I wouldn't even expect a text message!*

She walked quickly up Nugent Road, cut across Britten Crescent and down a side street onto Walgrave Square. In spite of the sub-zero temperature, her cheeks were flushed. She felt her heart pound against her ribs.

*This is stupid!* she thought. *Wim was totally cool about things. Why are you getting yourself all worked up?*

*Because,* the doubter replied, *behind the kind, understanding exterior, he really does see you as a lame-brain. He knows you don't have a clue about the sex stuff.*

'Ouch!' Frankie said out loud, pausing under a lamp at the corner of the square. She closed her eyes, and when she opened them again, she almost jumped out of her skin. 'Travis?' she said

to the huddled shape on the bench under the nearest tree.

Slowly Travis looked up. 'Frankie.'

'What are you doing out here?' She ran and sat by him. 'God, you must be freezing!'

'I'm OK,' he insisted. He had his hands pulled up inside his cuffs and his jacket zipped under his chin.

'How long have you been here?'

'Dunno. I was walking around, thinking, and I ended up sitting here for a bit.'

For a while Frankie didn't say anything. She looked up through the bare branches at the stars, casting her mind back just two weeks, to when Travis was with Sinead, and she, Sinead and Marina had stood shoulder to shoulder and shared all their secrets. 'What's happened to us lately?' she sighed.

'Meaning?'

'How come everything fell apart? This is Christmas. It's supposed to be the season of parties and presents.'

'Yeah, and now we all hate each other,' Travis chimed in. 'Except for Marina and Rob, and they're so into each other I don't like being in

the house in case I get in their way.'

'Is that why you're out here, or is this still about Sinead?' Frankie got ready for a heart-to-heart.

'You guessed it,' he admitted. 'Did you see her with that Boz guy?'

She nodded. 'That was more him than her, believe me.'

'But she wasn't exactly fighting him off.'

'Well, it's flattering when the guy on the stage comes on to you. The point is, Travis, this is gonna keep on happening. Sinead is so drop-dead gorgeous, she'll always have blokes buzzing around.'

'Don't tell me,' he moaned, his head in his hands. 'Listen, Frankie, I felt sick. I had to get out of there.'

She leaned over and put an arm around his shoulder. 'As bad as that, huh?'

'Worse,' he admitted. 'I don't know how I'm going to get through this, seeing her every day in college.'

'You'll get through it. People do,' was the best Frankie could come up with.

They sat together in silence.

'So what are you doing here?' Travis turned the tables on Frankie. 'Where's Wim?'

'I left him at Lee's,' Frankie replied, her heart sinking further. Now it was her turn to answer the hard questions.

'He let you walk back alone?'

'I said I wanted to.'

'Did you have a row?'

'No. He was tired.'

'He's a git,' Travis muttered. 'You don't let a girl walk home alone.'

'Actually, things didn't go that well,' Frankie sighed. 'Wim wanted to – y'know – and I didn't really – oh God, Travis, I think I blew it!'

This time, his arm went around her shoulder. 'You did OK,' he assured her. 'If it didn't feel comfortable – well, you've got the right to make that clear.'

'"Just say no!"' Frankie laughed, feeling tears spill down her cheeks. 'It's not cool though, is it?'

'Cool-schmool.' He was glad she was able to let it all out. 'I'm telling you, Frankie, you handled that well. And now, if Wim calls you it means he's serious about you. If not, you're well rid.'

'I know,' she cried. 'But he's gorgeous, and I am attracted to him, so why am I fighting him off?'

'Because you're not ready,' he said.

'When *will* I be ready?' Frankie asked, looking up and letting Travis see in her tear-stained face that this was a big issue for her.

By which he understood that Frankie had never gone the whole way with a man, and that her ignorance undermined her and stole away her confidence, despite her beauty, so that, like him, she just wanted to crawl under a stone and die.

'Come here,' he said, wrapping both arms around her and gently stroking her hair.

# THIRTEEN

It should have been written in letters a mile high and bolted onto a cliff face like the famous Hollywood sign – THE WORST WEEKEND!

Through Saturday and Sunday Travis stayed in at Number 45 and dulled his senses with wall to wall premiership football and horse racing from Wetherby.

Frankie clung to her phone, waiting for the miracle to happen. New Messages 0. No Missed Calls. The only times she emerged from her room were to make coffee and go to the bathroom.

Next door, Sinead turned her music up loud and sketched like there was no tomorrow. She went geometric and eastern, like Issy Miyake,

157

switched to the soft flow of Stella McCartney, then the plunging necklines of La Perla and the sheer sex-on-legs of Gucci. She buried herself in dress designs, fixated on fashion, cut out the part of her life that she couldn't reduce to patterns, pins and stitches.

**This is a ghost house,** Marina blogged on the Sunday evening. **What happened to the fun girls who used to live here? All I see is empty mugs and unopened mail.**

**To bring you up to speed – Frankie blew it with her Juggler Man, Sinead likewise with Travis. I'm living with two broken hearts, and it's no fun. Rob and I are cool though. He's coming to meet my family at Christmas. My dad will give him a hard time, checking him out, protecting his little girl. My mum will feed him turkey and pud. The usual stuff.**

**Did I mention that I love my gorgeous, hunky, silent, smouldering biker of a guy? OK, so a girl may not want to know which \*\*\*\*er scored an own goal against Liechtenstein when she finds herself alone in a room with him and his stone polisher. And OK, he drinks enough for a whole**

**soccer team. But I forgive him and adore him. I truly do!**

On Monday Frankie had a hard time dragging herself into college after a third sleepless night and a still-empty message box. But at least the cheque from Bed-Head had arrived, together with a new date for her diary – a fashion shoot for one of the glossies scheduled for early January!

*If this carries on, I'll soon have the money for a deposit on a new flat,* she told herself on the bus journey into town, forlornly checking and rechecking her messages. Why hadn't Wim got in touch? Had he really been so shallow that when she'd said no, he'd totally lost interest? 'I don't believe it!' she muttered out loud, drawing strange looks from the two schoolkids sitting opposite. *Text me!* she pleaded silently.

But her phone stayed stubbornly silent as she hopped off the bus and used a college side entrance.

'Ah, Frankie McLerran!'

*Uh-oh!* She shrank back against the wall, but

it was no good, Claudia had spotted her from inside her office.

'Come in and close the door behind you.'

Gritting her teeth, Frankie obeyed. 'If it's about last Friday . . .' she began.

'Sit,' Claudia ordered from behind her neatly organised desk. 'Don't give me any feeble excuses, just answer my question. How long have you been here at Central College?'

'Almost one term.' Frankie bit her bottom lip and fiddled with the buckle on her big canvas bag. Claudia Brown was only five-foot two, but she was one scary lady.

'How long would you guess I've been here?'

'I don't know.'

'I've been teaching jewellery design for centuries,' Claudia went on wearily. 'Thousands of students have passed through my hands and, to be honest, most of them were instantly forgettable, with minimal talent and zero commitment.'

Frankie frowned and nodded. Where was this leading?

Claudia clasped her hands, thoughtfully tapping her lips with her extended forefingers. 'I

had you down as different,' she went on. 'I thought of you as one of the few who come to the college with a burning desire to design fantastic jewellery, someone with real inspiration and imagination.'

'I did. I am,' Frankie murmured. Ever since she was a little kid she'd been making brooches out of modelling clay, bracelets out of plaited leather, necklaces out of brightly coloured glass beads.

'So what happened?' Claudia demanded. 'Where's the commitment that keeps you coming to classes? Where's the imaginative fire?'

'I'm having a bit of a hard time at the moment,' Frankie began. How lame was that?

'Don't tell me. Let me guess. It's a man.'

'Partly. And partly the new modelling work, which I need to do because of the money. On top of that, I'm not getting along with the two girls I share a house with.'

'How bad is your domestic situation?' Claudia asked, her voice softening.

'I'm looking for a new place.'

'OK, so you're homeless, poverty-stricken

and heartbroken, and I have some sympathy with that. But instead of skipping classes and falling behind, try and use work as a framework to get you through.'

Frankie nodded.

'If you don't, and you can't meet your deadlines, then everything falls apart.'

'I know.'

Claudia leaned forward, ignoring the phone on her desk that had begun to ring. 'You're a gifted designer, Frankie. If you weren't, I wouldn't be wasting my time like this.'

'Thanks.'

'But remember, success in our world relies mainly on hard work, despite the glamorous image.'

'I know. I understand.'

'Good.' With a nod, Claudia signalled for Frankie to leave. 'I hope you can sort out your problems,' she added, picking up the phone. 'Oh, and by the way, happy Christmas.'

'Happy Christmas,' Frankie replied, shutting the door and walking down the corridor like a prisoner reprieved from Death Row.

*

'Why not text *him*?' Katrine asked Frankie after Tristan's last fashion design lecture of the term.

'Yeah, that's what I would do,' Katrine's friend, Daisy, added. 'Why wait for it to happen the other way around?'

Frankie considered their advice, thinking that maybe it had been a mistake to spill the beans to girls she hardly knew. But the strain of waiting for Wim to get in touch had proved too much. 'You don't think it would make me look too needy?' she asked.

Katrine shook her head. 'Who cares. This is the twenty-first century, not the nineteenth. You're acting like some wishy-washy Jane Austen heroine.'

Daisy agreed. 'Anyway, it's best to get it out into the open. If this Wim guy isn't into you, you need to know sooner rather than later.'

'You're right – in theory,' Frankie agreed. 'I just don't want to risk totally blowing it, that's all.'

'She's a hopeless case,' Katrine said to Daisy, tutting and veering off down another corridor.

'OK, I'll do it!' Frankie called after them, going into panicky reverse gear.

**Hi how r u**, she texted, then hastily programmed in Wim's number. But her finger hovered over the '**Send**' button.

'Whoah!' Lee cried, almost bumping into Frankie as she sped round a blind corner. He was carrying an A1 drawing board covered in cartoon characters for his latest moving images animation project.

'Lee!' Frankie caught the bottom edge of his board before it slipped from his grasp. A question escaped from her lips. 'Hey, have you seen Wim lately?'

Lee narrowed his eyes and shook his head. 'Not since Saturday.'

'How come?'

'I'm not his keeper, am I?'

Frankie saw that the conversation was sliding rapidly downhill, but she couldn't put on the brakes. 'He is living with you, though?'

'*Was*,' Lee insisted. 'Not any more.'

'You mean, he left?' Unable to disguise a look of agony, Frankie kept hold of Lee's drawing board like a drowning man clinging to driftwood.

'I threw him out,' came Lee's abrupt answer.

'You didn't!'

'I did!'

'When?'

'The day before yesterday. Listen, will you let go of my board!' Lee pulled, but Frankie hung on.

'Why?' Indignation flushed hotly in her cheeks. 'You know the circus has to fold, don't you? Now the poor guy has no job and nowhere to stay!'

'Poor guy, my arse!' Lee snapped back. 'If you really want to know why I threw him out, it was because he never paid me any rent like he promised, and then, on top of that, a few things went missing.'

'What things?'

'A leather jacket, an i-pod, some cash . . .'

Frankie gasped. 'Did you ask for an explanation? Did Wim deny it?'

'I never gave him the chance.' At last Lee succeeded in wresting the board from Frankie's grasp. 'It wasn't rocket science to work out where the stuff had gone. But you know what makes me maddest?'

Frankie shook her head.

'That I was the idiot who believed his con-man story about having nowhere to stay in the first place. I played Mr Nice Guy and laid myself open to being robbed.' *Of possessions and of you*, Lee thought, which accounted for the depth of his anger.

'This can't be true, Lee. Wait here. I'll text Wim and find out what's really going on.'

'Don't bother, I'm not interested.' Lee was already on his way, the soles of his shoes squeaking on the polished floor.

`Call me` Frankie texted Wim. `We need 2 talk`

Sinead discovered that there were a thousand different blues, from ocean blue to teal, from sapphire to turquoise. Some blues were almost grey, some nearly purple. They ranged from cool and calm to richly royal.

'Are you still pursuing your pirate theme?' Tristan asked when he found her poring over swatches of fabric in the cutting room.

'I've broadened it to anything to do with the sea, really. I want to go for aquamarine and silver, maybe a powder blue with ultramarine.'

'Think about introducing white piped edgings,' her tutor suggested, studying some of her latest drawings. 'These are certainly an antidote to the current lousy weather. They make me think of sunshine and white sand, tiny islands in the Indian Ocean.'

'Am I on the right lines?' Nervously Sinead asked for an outside opinion on the designs she'd been slaving over all weekend.

'Yes – if you can avoid the usual clichés like sailor collars and navy blue and white stripes.'

'Thanks.' Staring out of the window as Tristan walked off, Sinead's eye wandered from the rain-filled sky, over the slate roofs opposite, then down into the quad with the fountain, and along to the brightly lit ground-floor coffee bar, where she glimpsed Marina and Rob with a crowd of photography students, including Travis. Her heart did a little flip, then she steadied it and refocused on her fabrics. She wondered about a teal blue, bolero-style jacket with wide lapels over a loose white cambric shirt, teamed with cropped, braided trousers. And eventually Travis drifted out of her mind.

*

Twice during the day Frankie had called Wim and left a message. There had been no reply, and by late afternoon the battery on her phone had run low.

`Am going home,` she texted in desperation. `Pls get in touch`

Home to an empty house, wondering if Wim was OK, still refusing to believe these latest bad things that Lee had said about him. *Maybe he's ill*, she told herself, obsessing about the subject. *That's why he hasn't contacted me. Or maybe a member of his family isn't well, or else his phone can't receive a signal for some reason, or it's broken or stolen.* In fact, there could be a hundred different, innocent explanations.

She was turning her key in the lock, looking over her shoulder at the already darkened square, when a familiar deep, foreign voice startled her.

'Crazy girl,' Wim said, stepping out from under a tree. 'It's me.'

Frankie froze as he approached.

'Open the door,' he said. 'I'm cold. Will you let me in?'

# FOURTEEN

'Where have you been?' Frankie demanded, once the door was closed and she and Wim were inside in the warmth. 'Why didn't you call me?'

'I've been busy.' He slung a rucksack from his shoulder onto the floor. 'My phone was out of credit, so I was waiting for you to get in touch with me. I thought maybe we weren't friends any more.'

'Why wouldn't we be?'

'I don't know. I felt I was out of line on Friday night. And I should have walked you back here.'

Frankie nodded. 'Yeah, probably. But listen, it's cool. So what's new with you?' She left the question open, waiting for him to tell her he was homeless.

169

'Lee threw me out,' Wim told her, totally up-front, his clear grey eyes untroubled. 'Some crazy stuff about an i-pod that went missing.'

'Did he accuse you of taking it?' Getting the story from Wim was important to Frankie, so she could judge for herself what had gone on at Nugent Road.

'What would I want with his stuff?' he shrugged. 'My guess is, it'll turn up under a pile of old newspapers or in his bed. The guy lives in a pigsty. Anyhow, that was only the excuse for getting rid of me.'

'How come?' Leading Wim through from the hallway into the living room, Frankie drew the curtains and turned up the central heating.

'Never mind,' he protested awkwardly. 'It's not important.'

'But it is. I want to know why Lee needed an excuse.' Now that she was over the shock of Wim turning up on the doorstep, Frankie needed the whole truth. She sat down next to him on one of the big floor cushions in the deep bay window.

'It's childish.' Wim seemed embarrassed. 'Lee

and I had this fight on Saturday morning – well, more of a scuffle than a full-on fight.'

'About what?'

He hesitated, then came out with it. 'It was over you, actually.'

'Me?' She laughed out loud.

'Frankie, this is serious. It turns out Lee has had a thing – an obsession – with you, ever since he first set eyes on you.'

'Oh God!' Yes, Velcro Boy used to follow her down corridors and hang around in Walgrave Square. 'You mean, he was jealous of you and me – that's why he threw you out!'

'Exactly,' Wim sighed. 'I've spent two nights sleeping on a friend's floor, waiting for you to call me.'

'You poor guy!' Frankie shuffled closer. 'Things couldn't get much worse, could they?'

'It's the life I lead,' he shrugged. 'The winter's always hard. Come spring, I can go back to Paris or Barcelona and entertain the tourists.'

'It must be weird, not having any roots, just drifting.' Frankie found it hard to imagine. 'Kind of exciting and romantic, but scary too.'

'I like it,' Wim insisted. 'I get to see great

places, meet interesting people. A nine to five job would be like a prison for me.'

'So what now? How will you survive until spring?'

'Who knows? Let's live for the moment, huh?'

She nodded slowly. Hearing the truth from Wim was like feeling a sharp sliver of ice melting in her heart. 'I'm so glad you came to find me. I've had a lousy weekend without you.'

'Me too.'

'But you're here now.' Smiling, she stroked his face. 'Everything's cool.'

'Hey, crazy girl,' he breathed, leaning forward to kiss her gently on the lips. 'What did I tell you? We live for the moment, you and I.'

'Whose bloody bag is that?' Marina stumbled over a rucksack that had been dumped in the hallway. She rubbed her shin then limped into the living room.

'Not guilty,' Sinead said. She and Marina had left college and travelled home on the bus together. Marina had been telling Sinead about the merit she'd just received from Jack Irvine for life drawing. 'Must be Frankie's.'

'Oh God, that means she's packed her stuff and she really *is* leaving!' Marina wailed. 'Look, I'm gonna have a giant bruise on my leg, damn it!'

'Hang on, it doesn't look like hers.' Sinead studied the rucksack more closely. Then she tried to pick it up. 'It weighs a ton!'

Marina hobbled back into the hallway and stared at the bulky foreign object. She glanced up and caught Sinead's eye.

'Wim!' they said in the same split second.

'Oh no!' Sinead backed off into the living room. 'Are you thinking what I'm thinking?'

Marina nodded. 'We have one mega-tall, ball-juggling Dutchman ensconced in Frankie's room.'

'What are we gonna do?' Sinead wailed.

'How could she?' Marina spluttered. She was all for dashing upstairs right there and then. 'She knows we hate his guts!'

'Wait!' Sinead did her usual thing of trying to avoid confrontation. 'Let's not jump to conclusions. Maybe he just dumped his stuff here.'

'No, he's up there – listen!' Straining to hear

the voices inside Frankie's room, Marina nodded. 'I don't believe this, Sinead. I didn't think Frankie would have the nerve!'

'It's Wim. He can twist her around his little finger.'

'But you know what happened at the week-end? It's all round college – Wim stole some stuff from Lee and Lee threw him out.'

'Maybe Frankie doesn't know that yet.'

'Then we'd better bloody tell her!' Marina got halfway up the stairs, then Frankie's door opened and Frankie came out onto the land-ing.

'You ought to know, I've asked Wim to stay here,' she said in a calm but defiant tone, stand-ing with her legs set wide apart, her arms folded. 'He hasn't got anywhere else to live at the moment, so I said it would be OK.'

'It's so *not* OK!' Marina tried to drill this into Frankie's thick skull.

The three girls were in the kitchen. Wim was keeping a low profile, upstairs in Frankie's room.

'For a start, we don't have enough space,'

Sinead pointed out. 'The house isn't big enough for four people.'

'Wim isn't here permanently,' Frankie argued. 'It's only until something better turns up.'

*Yeah!* Marina thought darkly. *Frankie, don't you realise that's the way he views you? 'OK until something better turns up.'*

'Second, Wim is the guy we had the big row over, in case you forgot.' Sinead was still smarting from the insults Frankie had flung her way – how she was twisted and bitter over Travis and not willing to let anyone else have a fun time. 'You can't expect us to welcome him with open arms.'

'Yeah, Frankie!' Marina agreed. 'Wim is a low-down cheat, and if you still can't see it, I'd say you needed one huge pair of mega-strength glasses!'

Frankie shook her head wildly. 'You two don't know him. You haven't given him a chance!'

'I gave him a big chance when I went round to Lee's place,' Marina reminded her. 'He grabbed it with both hands, remember?'

'God, you two are so – narrow-minded!'

Frankie flung at them. 'Just because he flirts, and women find him attractive, you've got a big down on him.'

'Grow up, Frankie,' Sinead sighed. She stiffened and fell silent at the sound of footsteps coming down the stairs.

'If you don't let him stay, I'll never speak to you again!' Frankie hissed, before Wim came into the room.

Then there was the longest, deepest silence. Wim broke it with, 'No worries, crazy girl. If there's a problem about me staying, I'll find somewhere else.'

'That sounds like a good idea,' Marina snapped, deliberately turning her back. 'Go find someone else to sponge off, sonny boy.'

'No!' Frankie sprang to his defence. 'Sinead, this is your house. You have the final say.'

Sinead felt three pairs of eyes bore into her. She saw bolshie Marina march into the hallway and start to drag Wim's bag towards the front door. And then the desperate look in Frankie's eyes, and finally Wim's cool, casual stare. *He doesn't care!* she said to herself with a sudden, sharp jolt. *The guy's got no feelings*

*whatsoever!* 'I'm sorry, Frankie, he can't stay,' she said flatly. 'That's it. Finish. Get him out of here.'

'I don't know whether to laugh or cry,' Frankie told Wim.

Together they'd left Number 13, taken a bus into town and got off outside the Roundhouse. They'd gone inside and Wim had ordered two large glasses of red wine from the bar.

'Always better to laugh,' he advised. 'Staying at your place would have turned into a French farce, with me opening bedroom doors and tiptoeing down corridors to see if the coast was clear.'

'It feels more like a tragedy to me,' Frankie sighed. 'Like I've been thrown into exile, never to return!'

'All for the sake of the one you love.' He grinned ironically. 'Come on, drink up. Let's get pissed, then everything will work out fine.'

'I shouldn't have done that,' Sinead murmured, staring through the open door of Frankie's room.

177

Frankie had grabbed an overnight bag, flung in a change of clothes and her toothbrush, left the drawers open and her bed unmade.

'You couldn't give in,' Marina insisted. 'And no way should Frankie have put you in that position to start with.'

'What should we do now?'

Marina shook her head. 'Maybe I'll call Rob.'

'To ask his advice?' Sinead nodded, then contradicted herself. 'No, wait. Let me ask Travis. He knows Frankie better than anyone. He'll be able to tell us what to do.'

'Yeah, call him,' Marina agreed.

They both felt a knot of anxiety grow larger in their stomachs as they thought of Frankie on the loose with Wim, with nowhere to stay.

'More wine?' After the first two glasses, Wim had used his credit card to buy a whole bottle. He poured freely into Frankie's glass.

'What time is it?' All of a sudden, the numbers on her watch face were fuzzy. She had to concentrate to stretch out her hand and pick up her glass without spilling it. *I'm drunk*, she told herself with a slight feeling of amused surprise.

'It's early,' he assured her. 'Hey, here's Natasha! Natasha, come and join us!'

Frankie watched Wim make room at the table for the red-headed acrobat she'd once seen rehearsing.

'Natasha, you remember Frankie?' Wim introduced the two girls. 'Frankie – Natasha. Natasha – Frankie.'

Travis recognised Sinead's number on the tiny screen and fumbled to answer his phone.

'Hi, it's me.'

'Yeah, hi.' He could hear a flutter in her voice, as if she was upset. 'What's wrong?'

'Maybe I shouldn't be dragging you into this, Travis, but we just had another row with Frankie. She stormed out.'

'You sound worried.' Weird for them to be talking again, great to hear her voice, sad that it was about someone else.

'I am. She went off with the Dutch guy, and I don't trust him.'

'Frankie's a big, grown-up girl,' Travis reminded her. Then his own worries kicked in. 'No, forget I said that. You're right, I don't trust

him either. Do you know where they went?'

'No, that's the problem. He's got nowhere to stay since Lee kicked him out. That's why he came round here, scrounging some floor space. The trouble is, Travis, *we* can't call Frankie because there's no way she'll answer the phone to either me or Marina.'

'But you think she'd talk to me?'

'Yeah. Could you just check that she's OK, then ring me back?'

'What do you want me to say to her?' Travis spun out the conversation, hanging on to every word Sinead said, every breath she made.

'Ask her to come and talk things through with Marina and me. Tell her we're worried about her.'

'What if she won't listen?'

'Then try to get her to come and see you instead. She trusts you, Travis. Let her know that you're there for her.'

He went to the window and looked across the square at Number 13, hoping to see Sinead in the window of her own house. She wasn't visible. 'I'll do it,' he promised.

'Thanks. I owe you one,' Sinead said, then rang off.

But when Travis rang Frankie's number there was no reply.

*The person you called is not available. Please try later.*

'How old are you, Frankie?' Natasha asked while Wim was at the bar in the Roundhouse.

'Eighteen.'

'Oh, a baby.' Natasha was Croatian. She was double-jointed; she smoked thin roll-ups.

'How old are you?' Frankie returned.

'Twenty ... something! What do you do, Frankie?'

'I'm a fashion student. How come the circus had to finish?'

'It did?' Natasha raised her eyebrows. 'Oh yeah, it did. These things happen.'

Wim came back with another bottle. 'Here you are, girls. And cheers, Natasha. Thanks to you, I didn't freeze to death this weekend.'

Frankie refused a drink and frowned. 'You stayed at her place?'

'She's my good, good friend,' Wim declared,

slinging his arm around the acrobat's shoulder.

'I had a spare room,' Natasha explained. 'But then my girlfriend called to say she wanted to move back in.' During a long swig of wine, she rolled her eyes towards Wim. 'Which, by the way, she never did.'

'Aha!' he cried. 'You are a darling, Natasha, the best friend a guy can have!'

'And you're drunk,' Natasha sighed. 'I take it you want to stay in my spare room again?'

'We do!' he declared, flinging his free arm around Frankie. 'We so do want to stay in your spare room!'

'Frankie's phone must be turned off,' Travis told Sinead, standing on the doorstep of Number 13. 'I've tried her number half a dozen times, but she never answers.'

'Come in,' Sinead invited him nervously. 'Marina's gone to work, so the house is empty.'

Natasha's basement flat was off Blackwater Road, backing on to a scrap metal yard surrounded by a tall chain-link fence. 'The water supply is a health hazard and the shower is

dodgy,' she apologised to Frankie. 'But hey, the rent is cheap.'

'It's fine,' Frankie swore. 'We're just really grateful, thanks.'

'Wim knows where everything is,' her hostess yawned as she slouched off to bed.

'Is it me, or does this ceiling slope?' Frankie asked Wim, sinking onto a wooden chair by a table covered in a sticky plastic cloth.

'It's you,' he laughed.

'No, it slopes! Look!'

'OK, it slopes. Come on, our room is through here.'

Taking her by the hand, Wim led Frankie into a bedroom just large enough to fit a single bed and a tall cupboard. There was no window, and only a bare bulb hanging from the ceiling.

'So romantic for my little crazy girl,' Wim joked.

Frankie didn't care that the bed was covered in an old blue sleeping bag, or that the brown carpet was frayed. She only wished that she could lie down and go to sleep.

'Take these off.' Wim helped her out of her jeans and sweater, lifted the sleeping bag and eased her into bed. Then he undressed and

climbed in beside her. He reached up and turned out the light.

*It's really happening!* Frankie thought in an out-of-the-body way, as Wim moved in. It was pitch black and silent. Exciting. Unknown. *Is this how it's meant to be?*

# FIFTEEN

'Ah, nice to see you, Ms McLerran!' Claudia treated Frankie to a heavy dose of sarcasm in the jewellery workshop first thing on Tuesday morning. 'Tell me, what are your thoughts on your first term's work?'

'Could do better!' Frankie muttered. She was struggling to finish an extra-curricular bracelet that she'd been planning to give to Sinead as a Christmas present, but would now have to give to her mum instead. The bracelet was definitely more Sinead, though – a fine silver band with delicate silver stars gathered in a cluster around the fastener. She took off her goggles and looked up at Claudia. 'Seriously, I think the ethnic stuff has worked pretty well.'

'Me too,' Claudia agreed. 'But you were right

with your first remark – you could still do better. And that's what I'm expecting from you next term.'

'Slave-driver!' Daisy groaned, as the tutor moved on. 'She gave me a C– for my last project, mean cow.'

'Yeah, she's hard to please.'

'Let's hope she doesn't come to the party tonight.'

'Party?' This was the first Frankie had heard of any party.

'Yeah, staff and students. We're all getting together at Escape.' Daisy gave Frankie a funny look. 'Didn't Marina tell you?'

'I must've forgotten,' Frankie mumbled. She said no to coffee with Daisy and a couple of others, staying behind to tidy her bench instead.

Weird – of the two big events that had just happened to her, the split from Marina and Sinead preyed on her mind more than her night of passion with Wim.

The physical thing had been cool – some nice bits, some scary, unknown bits, and overall an experience that she might want to repeat in the not-too-distant future. But the earth had stayed

firmly in place – no movement of tectonic plates.

'Good to get the first time over with,' Wim had said. He'd been warm and affectionate, responsible, very grown up.

She pictured the fumbles and awkwardness of two first-timers – nightmare. How nice then, to have an experienced partner like Wim. And she did feel different – older, glad to have completed a rite of passage. Yeah, it was definitely an important thing.

So why this flat mood now, after she and Wim had showered in Natasha's wonky shower and dressed in the freezing cold flat? Shouldn't she be floating on air, or did everyone get this anti-climax?

'I adore you!' Wim had told her in an amused tone, over a fast-food breakfast.

She'd grinned back at him. 'You make me sound as if I'm a cream cake or a strawberry trifle.'

'Huh?' Wim's mouth had been full of bagel and cream cheese.

'Like I'm a treat, but too calorific for every day.'

He'd shaken his head. 'Crazy girl!'

And she hadn't been able to say she adored him back. Why not?

And now she just wanted to be alone, not gossiping with Daisy, or giving her the obligatory blow-by-blow account. She wanted to be working and thinking, wondering how to get back on speaking terms with her two best mates.

*I could say sorry*, she realised, counting out the pearly, greyish-pink tourmalines in her neat box of semi-precious stones. *Except I don't know what I'd be saying sorry for.*

*For losing it with them.*

*I had every right. No one interferes in other people's relationships, not if they want to stay friends.*

*You could say sorry anyway. Make the first move.*

*They'd think it was only because I couldn't find anywhere else to live.*

*No, Sinead's not that shallow. She'd know you meant it.*

*But Marina. She's the one who threw Wim's rucksack out onto the pavement last night.*

*Yeah, she's the tough one. If Wim is still in the picture, no way will Marina accept the apology.*

Frankie sighed then started on her seed pearls – one, two, three ...

The day had begun badly. Travis's photography tutor had collared him and given him a bollocking for wasting chemicals in the developing lab. An innocent Travis had answered back, but come off worst. Then he'd lost a roll of film by letting light into his camera.

*But*, he thought, *Sinead is talking to me!*

She'd invited him into Number 13, they'd sat and had a drink, discussing what to do about Frankie, coming to no conclusions.

'It stinks,' Sinead had sighed, curled up on a floor cushion in her zigzaggy pink-and-white shirt and cowboy boots.

'Maybe it'll all work out,' had been the best he'd been able to come up with.

But they'd talked, and then he'd gone home, and now Travis believed in miracles.

'Sinead, tell your mother happy Christmas from me!' Tristan called across the cutting room.

'She's in Prague. She went last night.' Sinead was matching fabrics against her latest

sketches, planning to zap off one of her designs on the sewing machine in time for tonight's staff-student do.

Looking casual and unusually crumpled, Tristan came over for a chat.

'Try that mint-green chiffon with an apple-green satin,' he couldn't help suggesting. Then, 'So what will you be doing for Christmas, if your mum's not in Dublin?'

Sinead shrugged. 'I don't know. I could still go home, or maybe I'll stay here and work.'

'By yourself?' he asked. 'Forgive the unlooked-for paternal interest.'

Another shrug.

'I knew you as a babe in arms, remember. Your mother and I go back further than I care to recall.'

So, the usually immaculate Tristan was human after all. Sinead smiled gratefully at him. 'I'll be fine.'

'Are you coming to the party tonight?' he asked.

She nodded. 'As long as I can make myself something decent to wear!'

\*

```
theres    a    party    at    escape,
```
Wim
texted Frankie.

```
i    knw,
```
she texted back.

```
lets    go
what    time
8.30
cool
```

```
wot    u    wearing    2nite,
```
Marina texted
Sinead.

```
green    dress
am    at    home    can    I    borow    shus
which    1s
gold    sandals
cool
```

This was one night when Marina didn't mind
working, she decided. Serving behind the bar,
she would be in a good position to see who was
getting off with whom, who was getting drunk
fastest, which members of staff were behaving
badly, and generally becoming the fount of all
useful knowledge.

Besides, Rob was the DJ, and these days there
wasn't anyone else Marina felt like dancing

with, except maybe Travis if he was looking lost and lonely.

Marina grabbed Sinead's gold sandals, put them in her bag, and, dressed in her biker leathers, went across the square to find Rob.

'Are you going to the party like that?' he asked, halfway through shaving.

'Yeah,' she kidded, catching sight in the bathroom mirror of a girl she wouldn't have recognised a couple of months ago – no make-up, hair tied casually back, loved up. 'No, I've got my stuff with me. I'll get changed at work.'

'Which shirt shall I wear?'

'Hmm, the off-white one or the off-white one?' Marina went into his room and searched for something that looked as though it might have once seen an iron, gave up and brought him a well-worn dark-brown sweatshirt . 'This?'

'No, my mum gave me that. I need something funkier.'

'You don't do funky – only disgustingly dishevelled!' Marina giggled. 'Rob Evans, I can't believe we're having this discussion about what *you* should wear! Shouldn't it be the other way around?'

He grinned sheepishly. 'Anyway, you always look cool,' he told her, staring in the mirror and running his fingers through his hair. 'You're the fashion student. You have to help me with my image.'

'Don't make me laugh,' she pleaded, feeling the giggles take over.

'What did I do?'

'Don't look so serious, please! Oh stop, Rob!'

'What? I mean it – you have to look right in this job.'

Marina sat on the edge of the bath, laughing helplessly. 'I'm sorry. I can't help it . . .'

Turning from the mirror, he put both arms around her waist, lifted her off her feet and kissed her.

'Stop, Rob! We're gonna be late. Put me down!'

'Not until you tell me I can do funky.'

'OK, OK, you can do funky. Now stop!'

'Do you love me?' he demanded.

'Yes, I do – totally – deliriously – seriously . . .' Marina slowed down to return his kisses. '. . . love you!'

*

The first bad thing about going to the party with Wim was that Frankie would have to nip back to Walgrave Square to pick up something to wear.

The second was that Sinead and Marina would be going too.

As it turned out, visiting the house went OK because she timed it right and showed up when there was no one in. It took her only a few minutes to sort out a white T-shirt which she'd embroidered around the neckline with chunky silver beads and thread (nothing too dressy for Escape), teamed with taupe trousers gathered at the waist and her soft, tan leather boots.

She didn't linger, finding that being back there still churned up action-replays of the rows and left her with big regrets about what had happened.

But she did stop to call in at Number 45, to explain to Travis why she hadn't returned his calls.

'I was kind of busy,' she told him, unable to hide a blush. 'And I'd switched my phone off.'

Travis was glad to see her. 'We were worried about you.'

'No need. I'm staying with Natasha until

Wim and I can sort something out.'

'Natasha?'

'A friend of Wim's. She's an acrobat.'

'Right.' Travis raised his eyebrows but didn't comment. 'As long as you're OK.'

Frankie spread her hands, palms upwards. 'Don't I look OK? Anyway, you said "we" were worried. Who's "we"?'

'The girls and me. Sinead mainly.' It was Travis's turn to look uncomfortable. 'She came across and asked me to call you.'

'So you two are talking again?'

'Looks like it.'

Frankie took a deep breath and considered the latest development. 'Cool,' she said at last. 'So are you all coming to the party tonight – Sinead, Marina and you?'

Travis nodded. 'You?'

'Yep,' Frankie replied. 'I'll be there with Wim.'

He cringed. 'Could be an interesting night. If there's another fight, just don't ask me to referee!'

'Promise!' Frankie said, waving Travis goodbye and running for the next bus to Blackwater Road.

*

'Hey, did you have a good day?' Wim asked Frankie. He greeted her with a friendly kiss.

She nodded. 'Did you?'

'I stayed in. Nothing happened.'

'Oh, but look at it this way – at least nothing *bad* happened.' Frankie was surprised that Wim hadn't wanted to escape from the dismal little flat into a library, say, or an art gallery. 'Did it seem like a long day?'

'Without you, a minute seems like an hour, an hour seems like a day!' Wim declared.

'You've read too much Mills and Boon.' Frankie laughed, seeing that he looked puzzled. 'Oh, Mills and Boon? Well, they're these . . . No, it doesn't matter, forget it!'

'Don't you like me to be romantic?' he teased, putting his arm around her waist and fiddling with her hair.

She kissed him. 'I have to get changed.'

'What for? Oh yeah, the party.' Wim watched Frankie disappear into the tiny bedroom.

'Yeah, the party. I didn't even know it was on until a girl at college mentioned it.' She came back, one arm already out of her sweater. 'Hey, how come you heard about it?'

'I told him.' Natasha seemed to have appeared out of nowhere.

Frankie blinked, glanced towards Natasha's bedroom door, then nodded. Their landlady was dressed in a black, Chinese silk dressing-gown and apparently little else. *Aren't you cold?* Frankie wanted to say, but didn't.

'I was in Escape at lunchtime,' Natasha explained. 'The DJ was setting up his system.'

'Was it a dark-haired guy in a leather jacket?' Frankie asked.

Natasha nodded. 'Hunky.'

'That would be Rob, Marina's boyfriend.'

'Hurry up, Frankie. It's seven-thirty and I need a drink,' Wim urged. 'Go make yourself look beautiful.'

Frankie heard Natasha's laugh as she retreated into their room.

'What's the rush? You were never early for anything in your life, Wim van Bulow!' Natasha's teasing had a scornful edge, then her voice turned soft and she switched to innuendo. 'Oh, maybe I can think of one thing!'

In her hurry to pull her T-shirt over her head, Frankie scratched her face on the chunky,

metallic embroidery. She covered the scratch with heavy foundation, put on lashings of mascara, blocked out the conversation in the next room.

'Amazing. You're a magician!' Wim said when she reappeared. 'I never knew a girl transform herself so fast.'

'Let's go.' Frankie was beginning to really dislike the cramped, musty flat. She'd squirted on a gallon of perfume to block out the smell.

'See you later,' Natasha told them, uncurling her legs and standing up from the one easy chair in the room.

Frankie turned in the doorway, almost colliding with Wim. 'Are you coming to Escape?' she asked Natasha.

'Sure thing.' Natasha tossed her red hair back over her black silk shoulder. 'You ask Wim – I never miss a party, do I, darling?'

# SIXTEEN

Watching your tutors partying was like catching your best friend picking her nose, Marina decided. You realised it was something everybody did, but you didn't particularly want to witness it.

Rob had kicked off the evening with Slade.

*'So here it is, merry Christ-mas, everybody's having fun!'*

A unanimous groan had gone up, but by the time Noddy was croaking *'Look to the future'*, the tiny dance floor at Escape was packed with students and tutors, arms raised above their heads, swaying to the beat.

'Cheesy, or what!' Marina muttered at Sinead, who had just shown up in a little green number that she'd 'run up on the machine'. She looked stunning as always.

'Hey, check out Claudia getting down and dirty with Jack Irvine!' Sinead gasped.

Marina stared in mock horror at the small, dark-haired jewellery lecturer literally letting her hair down and grinding her hips against the bewildered drawing teacher. 'John Travolta he definitely ain't,' she commiserated.

By now Rob had switched to an Oasis classic and the party was well underway. Sinead spotted Tristan, nattily dressed in a black shirt and loose jeans, hiding behind the cappuccino machine. 'Come and dance!' she ordered, refusing to take no for an answer.

'No!' he insisted as she dragged him through the crowd. 'No, no, no!'

'Party pooper,' she challenged. 'Daniella told me that you used to be the life and soul.'

'That was twenty years ago, darling.' Slowly Tristan began to shuffle from one foot to the other, vaguely in time to the music. 'And only after I'd had several Glenmorangies!'

'Cool!' Sinead grinned at him.

'Just don't hold it against me at a later date,' he warned, experimenting with a slight animation of the right arm. 'God, I hate these

staff-student get-togethers!'

'*Relax, don't do it!*' Sinead sang along with Frankie Goes to Hollywood. 'C'mon, Tristan, you have to unwind. No one's even going to remember seeing you dance after they've all got blasted out of their skulls!'

'Drink?' Marina gestured across the room to Rob, halfway through his first set.

He nodded, so she set off towards him with a brimming pint of lager, skilfully avoiding the rugby scrum of boisterous photography students.

'I thought you were trying to wean me off this stuff!' Rob yelled above a heavy metal number. He took a long swig before Marina could change her mind.

'I am, but this is a special night,' she cooed.

'How d'you mean, "special"?'

Marina gave him her Marilyn smile. 'Wait and see!'

Rob grinned then got busy with his decks.

'Play Damien Rice!' Daisy from fashion design pleaded.

'No, no, the Rolling Stones!' Claudia

countered. '"Jumping Jack Flash!"'

'Talk about culture clash,' Rob groaned. 'How am I ever gonna get this right?'

'So, Frankie says not to worry, everything's cool,' Travis told Sinead, picking her out the instant he walked into the bar. He hadn't gone straight up to her, though, but given her time to spot him and decide whether or not she wanted to talk.

In the end, Sinead had given Travis the briefest of smiles – enough of a signal for him to join her at the bar.

'When did you see her?' Sinead quizzed. She beckoned for Marina to come and listen in.

'A few hours back. She's staying at a flat belonging to a friend of Wim's.'

'*With* Wim?' Marina asked.

Travis nodded.

'How did she look?'

'Normal, I guess. No, actually there was something different about her. Calmer, quieter.'

'Is she coming tonight?'

'That's the plan.'

Marina scanned the room. 'What time?'

'Hey, back off with the inquisition!' he pleaded. 'I've told you everything I know.'

'Which is hardly anything,' Sinead complained. 'How come boys are so bad at finding out what people really need to know?'

'Not that we're generalising, or anything!' Marina laughed. 'Anyway, it's cool that Frankie's fine.'

'What?' Travis cupped his ear with his hand.

'I'm glad Frankie's fine!' Marina yelled.

Talking of which . . . Sinead leaned across the bar to nudge Marina. 'Look who just walked in!'

The couple were easy to spot. For a start, Wim stood six inches taller than anyone else in the room. And Frankie turned heads without even trying, with her dark hair loose and glossy, her white, sparkly T-shirt standing out under the disco lights.

'Did you notice how Daisy and her mates have started sucking up to Frankie since she got the modelling work?' Marina said darkly. She noted that Wim hadn't even had a chance to buy Frankie a drink at the other end of the bar, before the wannabes had clustered round. 'Until she got signed up by Bed-Head Katrine

Walker wouldn't even have given her the time of day.'

'Yeah, funny that!' Sinead sniffed.

'Miaow!' Travis said under his breath.

Sinead and Marina shot him filthy looks. 'You need to keep out of trouble while Sinead and I analyse the Frankie phenomenon,' Marina frowned. 'Go on, Travis – go and talk to Rob!'

'Not unless Sinead agrees to dance with me later,' he bargained. *Wow, where did that nifty piece of footwork come from?*

No way had Sinead been expecting that one. She took a drink to give herself time to think.

'Deal!' Marina said for her. 'Now go, Travis, and don't come back until I say so!'

After leaving the flat on Blackwater Road, instead of coming straight to Escape with Frankie, Wim had insisted on a leisurely pub crawl.

'You go on ahead if you like,' he'd suggested at the third bar. 'I'll finish this game of pool with Goran, then join you later.'

'I'll wait,' she'd decided, trying not to feel sidelined.

It had turned out that Goran was a cousin of Natasha's, a street performer and part of the circus crowd. Wim had thrashed him at pool then quickly invited him and his two buddies along to the party.

Frankie had gone with the flow, confused by the wave of eastern European consonant clusters lapping at her ears, impressed that Wim seemed to be able to chip in with a sentence or two of Croatian.

So arriving at Escape was a relief, not a trauma, as Frankie had expected. Here there were people she knew from her course, plus tutors making fools of themselves on the dance floor, and her lovely friend Travis standing with Rob behind the mixing deck.

Travis waved and came over, not even asking before he grabbed Frankie's hand and led her into the huddle of dancers.

'Why the big grin?' she yelled over the music, keeping one eye on Wim at the bar.

'Nothing. Just dance!'

'It's you and Sinead, isn't it?' Another glance at the bar revealed Sinead deep in conversation with Marina. 'Are you two back together?'

'No,' he said, too hastily, bumping into Frankie as someone barged him from behind.

'Methinks he doth protest too much!' she laughed, hugging him and teasing him some more.

'Hmmm,' Sinead said. She watched Frankie with her arms around Travis.

Marina pulled pints of lager non-stop. 'My upper arms will be oh-so toned!'

'Not good,' Sinead muttered.

'What are you staring at? Oh, that's nothing. Travis and Frankie are like brother and sister. Anyway, why should you care?'

'I don't.' Sinead realised Marina was right. She took a drink, tried to look away, but her gaze kept flicking back to Travis. *Him dancing with Frankie is one thing, but what if that was Katrine Walker or Daisy Maneater-Fenwick with her arms around his neck?* she wondered. *Ouch! No way would I be able to sit here calmly spectating!*

*Travis whispering into Daisy's ear.*

*Travis dancing a slow number, hip to hip.*

*Travis leaning in and delivering a slow, lingering kiss.*

Marina handed out change then glanced Sinead's way. She saw in a flash what torments her friend was going through. 'Yeah, that should be you and Travis out there,' she confirmed.

Slowly Sinead nodded. *Travis and Sinead, not Travis and some other floozy.* She stood up from her bar stool.

'Go, girl!' Marina said, watching Sinead and clucking like a mother hen.

'Don't ask!' Frankie told Travis, stepping back and fading into the crowd. She'd seen Sinead heading purposefully in their direction.

He looked confused.

Frankie held up her hand to show that her fingers were firmly crossed. 'Good luck!' she mouthed.

OK, so Sinead was making a move on Travis, Frankie had finally found Wim with a crowd of mates at the bar, Jack Irvine was busy holding Claudia upright, Daisy was making an unbelievable play for Tristan and Katrine was consoling a lonely Lee Wright. Marina kept

careful watch. The one person she didn't keep her eye on was Rob.

'You look like you need a drink.' Natasha approached the hunky DJ in a black tube mini-dress with a slinky silver chain belt and the highest red stilettos in the universe.

She was Cindy Crawford with red hair, she was the Body Beautiful. 'Where did you come from?' Rob asked.

Natasha raised an eyebrow. 'I came in through the door like everyone else.'

The body and the husky foreign voice made for a killer combination. 'Is there a track you'd like me to play?' he muttered, accepting a drink from her bottle.

'Not unless I get to dance with you too,' she purred.

He laughed and shook his head. 'Sorry. My girlfriend wouldn't like that.'

'Pity.'

Natasha left him with a lingering look, on the prowl in her slinky dress, ready to do real damage.

\*

'I blame Christmas,' Travis said.

He and Sinead had danced, then they'd slipped out from Escape to walk in the brightly lit streets.

'What's Christmas got to do with it?' Sinead slipped her hand into his and gazed up at a million twinkling fairy lights.

'Too much pressure, a ton of expectations. Your mother wants you to do one thing, my folks want it their way. Between them, it all falls apart.'

'But we shouldn't have let it,' she sighed. 'And it wasn't really Christmas that was the problem, was it?'

They walked on out of the city, where the streets were no longer in fancy dress.

'Y'know, I've never been in a relationship like this before,' Travis said quietly. 'With me, it's usually easy come, easy go. But with you, I have to dig deep into places I didn't know I had.'

'Is it that painful?' She shook her head in disbelief. 'Yeah, it is,' she agreed.

'Stuff like jealousy. I'm asking myself, "Why do I say things that I know will hurt you?" and not coming up with any answers until I've lost you and it's too late.'

'But it's not that simple,' Sinead pointed out, squeezing his hand. 'Look at us now. We're talking again. It feels right.'

'But still scary.'

'Hey, I'm the wobbly one around here!' The one who agonised over which shoes to wear, in case she got it wrong and failed to live up to her 'A' list mother's expectations.

Walking and talking. Hand in hand, past the wheelie bins and the cold cats sitting on windowsills, past an electric Santa and his Rudolph perched on a porch roof, into Walgrave Square.

'Your place or mine?' Travis asked.

# SEVENTEEN

Goran and his mates were a handful. They were loud and drunk and didn't seem to understand some part of the word 'no'.

'No!' Marina insisted, snatching her hand away before Goran could grab it as she gave him his change. 'I'm not coming out on a date with you!'

'Yeah, baby!' he insisted. 'You and me – together.'

'You and me – no chance!'

'You're beautiful!' Goran slobbered.

'And you're a gorilla.' What did it take to make this guy back off? Thankfully, Marina had the width of the bar between her and her latest admirer. Thankfully too, he was soon diverted by Wim.

'Hey, sexy!' Wim greeted Marina. If he had a conscience about coming on to her at Lee's place, he showed no sign of it now. He ordered beer, and soon he and the Croatians were scanning the room for further opportunities.

'Look out, there's Natasha!' Goran warned, pretending to duck out of sight.

As Marina took a knife and sliced wedges of lime, she watched and listened like a hawk.

'No problem,' Wim swaggered. 'Natasha's cool with me seeing other girls. She dates other guys. We have an open relationship.'

Marina gasped. She looked around for Frankie.

Meanwhile, Goran envied Wim. 'You're one lucky sucker!' he drawled. 'What about this latest chick?'

'Frankie? Man, she's crazy!' Wim laughed. 'Did you ever see a girl more gorgeous? And y'know, she doesn't even know it! With her, it's totally something she takes for granted, which makes her different from all the others. I like that.'

'So what? Are you just fooling around with her?'

Wim shrugged then smiled. He leaned close to Goran to whisper something in his ear.

Marina had to grasp the edge of the bar to stop herself from vaulting over it to smack Wim in the face.

Goran laughed out loud.

*Stay out of this!* Marina told herself. But if looks could have killed, Wim would be lying stone dead on the floor.

Frankie was in the ladies' room, giving herself a strict talking-to.

*You can do this! You can get through this lousy evening.*

*So what if Wim's mates are leching over you and he doesn't seem to care? You're a big girl. You can handle them.*

She leaned in towards the mirror to touch up her lip-gloss and flick back her hair.

*You're making a choice here. You have to be grown up. If you want to be with Wim, you have to learn his rules.*

Two girls came into the room and disappeared into adjacent cubicles. They chattered and giggled about the guys they'd pulled.

*OK, ready!* Frankie told herself, tugging at the hem of her T-shirt so that she showed less midriff. Then she pushed through the swing doors, back into the fray.

'I could kill that Wim guy!' Marina breathed fire over Rob, when he took a break and came to the bar.

'Calm down, babe,' he advised. 'It's not your deal, remember.'

'But why can't Frankie see it?'

'See what?'

'That you can't trust him as far as you can throw him.'

Rob grinned. 'Throw him?'

'What? Oh yeah, juggler – "throw him"! I'm serious, Rob. I just heard him admit that he's in a relationship with the woman whose house Frankie is staying in!'

'That's tacky,' Rob admitted. He saw Frankie emerge from the ladies' room, looking like a little lost girl who was trying to cowboy up. 'Y'know what?' he confessed. 'I could kill him too!'

<p style="text-align:center">*</p>

*OK, so where is he?* Frankie searched hard for Wim. Last time she'd seen him he'd been propping up the bar with the Croatians, looking as if they were giving Marina a tough time. But now he'd vanished.

She sagged a little, then squared her shoulders again. He must be here somewhere. She would find him, go up to him and brightly say, 'Hey, whatever happened to that drink you were supposed to get me?'

He would grin and offer her some of his beer, put his arm around her and call her crazy girl.

'Have you seen Wim?' she asked Rob, who was making his way back to his mixing deck.

Rob shrugged. 'No,' he answered truthfully. 'Frankie . . .'

'What?'

'Forget it, it's cool.'

*What was that about?* she wondered.

From behind the bar, Marina caught her eye and waved.

Frankie hesitated. She was on the point of waving back when she spotted Wim standing outside on the street, his back to the window.

She stared hard – yes, it was definitely him, in his sheepskin jacket, leaning forward, probably talking to someone.

Pushing her way out of the bar wasn't easy. 'Excuse me,' she said, 'can I get through? Thanks. Sorry . . . Excuse me.'

'Hey, crazy girl!' Goran called, lurching towards her.

She took a sharp breath and squeezed beyond his reach. *Cheeky bastard!*

At last she was at the door, escaping from Escape. The cold air hit her.

Wim was leaning forward, but he wasn't talking. He was snogging.

Frankie froze on the pavement, beneath the street light with the flickering Christmas angel. She could see the woman's arms around his neck, a glimpse of red hair . . .

Consciously making her legs work, Frankie walked towards them. 'Excuse me,' she said lamely, as if still pushing her way through the crowd.

Wim turned to look over his shoulder. When he saw Frankie, he stepped back from Natasha.

'Ah!' Natasha said. 'Huh. Start talking,

darling. Explain some things to little Frankie while I go and have a cigarette.'

'I never said you were the only one,' Wim said to Frankie, leaning back against the big plate-glass window.

Inside the bar, the music pounded. Outside, she could hear the receding *tip-tap* of Natasha's high heels on the pavement. She had a sensation of something inside her cracking and splintering, then falling to pieces.

'You know what I'm like, Frankie. I never hid anything.'

'Not good enough,' she told him. In fact, nowhere near good enough. 'Go ahead, Wim, start talking. I'm listening.'

'What do you want me to say? I was kissing Natasha.'

Once the pieces had shattered and fallen, Frankie felt strangely calm. 'Are you also screwing her?'

Wim shrugged.

'I take that as a yes. Were you screwing her when I came back yesterday and she was in that sexy little Chinese number?'

He was about to shrug again, when she stopped him.

'God, no wonder she said you knew where everything was. It wasn't only the flat she was talking about!'

'Where is this going?' Wim objected.

'You tell me.' Frankie took time to look straight into Wim's grey eyes, trying to read what was going on in there. 'Oh yeah, I forgot – you're the guy who lives for today.'

'Listen,' he said, going back to his first line of defence. 'Have I been bad to you? Don't you like what we have together?'

Frankie thought hard. 'You've stood me up or been late to every date we've had,' she reminded him. 'Plus, you took me back to stay in a flat with your long-term girlfriend. Yeah, Wim, actually you've behaved pretty badly.'

'If you say so,' he sulked.

'*Plus*, you most probably *did* take Lee's i-pod.' Everything began to stack up and make sense to her. 'And hey, were you ever really part of the circus, or just a guy who hangs out at the Roundhouse because that's where Natasha works?' It was weird how calm she felt. This

should have been a car wreck – instead, here she was, in the driving seat.

Wim turned away from her steady gaze. 'What's it matter?'

'It matters!' *I broke up with my friends over you, you rat! I believed in you!*

'You're very young,' he said, switching tack and speaking like a kindly uncle.

'Yeah!'

'When you grow up a bit, you'll see that this is how it works.'

'Bastard!' she threw back at him, suddenly blazing with anger. 'Absolute, total wanker! Don't come on to me with that crap.'

He shook his head, sneaking a look to see if anyone could overhear.

'For your information,' she yelled, 'this is *not* how it works, unless you happen to be a greedy, sneaky, totally immoral bastard like you!'

'Nice one, Frankie!' Katrine said, lurching out of Escape at the end of the party and wobbling towards her taxi.

'I'm out of here,' Wim said, hunched up inside his jacket.

'Just one more thing before you go.' Frankie

put her hand on his arm. 'You know you said that what you liked about me was that I was a free spirit? That was a lie too. What you liked was that I was so young and stupid that I would play it your way and do everything you said without a squeak.'

'That's not true. I do think you're special.'

'But not special enough to stop screwing Natasha.' That was it – the bottom line.

'Anyway, I have to tell you that this is what a free spirit looks like – not the little mouse who ran around lapping up your every word.'

'Whatever,' Wim muttered, looking around for rescue. He saw it in the shape of Natasha, teetering back along the pavement.

'Here's your acrobat,' Frankie sighed. She took one last look at her Juggler Man, who seemed smaller now, and nowhere near as handsome. 'Have a good life, Wim,' she said quietly.

She walked away before Natasha could join them. She didn't look back.

'We have to go!' Marina urged Rob.

The gig was finished, he was packing up his

stuff. 'Why? What's the rush?'

'Frankie! She was outside having a fight with Wim. I saw it through the window. She flounced off without him!'

'Shit,' Rob said. 'Where did she go?'

'That's just it, I've no idea. I mean, where would she go? It can't be back to his place, can it?'

'Get the helmets,' Rob said. 'I'll leave my stuff here. Come on, we've got to find out where she went!'

'Huh!' Frankie said out loud. The exhilaration of telling Wim exactly what she thought of him was rapidly fading, leaving her with a big hole in her heart which, until five minutes ago, her Juggler Man had occupied.

Love came in one door and exited by another, leaving a cold wind blowing.

'Bloody hell!' she muttered, striding up the hill. 'Oh well, that's it. End of story.'

Rob and Marina cruised the streets looking for Frankie. On the pillion seat Marina sat with her arms around Rob's waist, the visor of her

helmet pulled down to protect her from the icy wind.

The city was busy with Christmas clubbers. Gangs of girls and guys were transferring from pub to club, taxis were picking up and dropping off, police cars coasted by.

Rob looked out for a solitary figure – a girl in a white T-shirt, with long dark hair and nowhere to go.

'I'll never leave you,' Travis promised Sinead. They'd chosen Number 13, and were sitting with arms locked around each other's necks in the big bay window of the front room.

'You can't say "never",' Sinead sighed. Life didn't work like that – from what she'd seen when she was a kid, men came and promised her mum the world. Daniella believed them. Then, two years down the line, they were gone. 'No one knows what's going to happen, not even tomorrow.'

'Believe me,' he said. 'I'll always love you. I never want to be without you.'

'Travis, don't say that.'

'And I'll never be jealous, and you can go

where you want and do your own thing, and then we'll be back together and it'll be even more perfect than it was before . . .'

'Stop!' she pleaded. She had to put her hand over his lips to make him quiet. 'I – have – missed – you,' she said, delivering a kiss between each word.

*What a fool I've been!* Frankie said to herself, marching into Walgrave Square. *I fell for the man-of-the-world stuff – New York, Paris, Barcelona! And for the voice and the accent, and walking Sharon Stone's dog! Yeah, I fell flat on my stupid fat face.*

'It's no good,' Rob told Marina, stopping the bike by the kerb outside Escape. 'Looking for Frankie is needle in the haystack stuff.'

They'd circled the city centre and ended up where they'd started. 'This is a nightmare!' Marina wailed. 'What are we gonna do?'

Rob thought for a while. 'Where did Sinead go?'

'She left with Travis. I guess they went home.'

'I think we should tell them about Frankie.'

Marina took out her mobile and called Sinead, then Travis. 'They've got their phones switched off,' she reported. 'We'll have to go and tell them face to face.'

As Rob switched on the ignition and the engine roared into life, Marina did her best to quash the desperate vision of blue flashing lights ... police uniforms ... paramedics standing by ... of frogmen searching the black river by floodlight.

Frankie fished in her jacket pocket for her key.

*OK, so it wasn't all bad,* she told herself. *That night with Wim is not something I regret – hunky guy, sweet sensations. Hmm.* At least one good memory to carry with her.

She turned the key in the lock.

'Here's Marina,' Sinead warned Travis, before he got too passionate. She'd heard the click of the key in the front door and pulled away from him, begun tidying herself up.

*Oh my God!* Frankie thought. *What am I doing? I don't even live here any more!*

Rob and Marina rode into the square. Rob eased around the corner and parked quietly under the trees. Marina jumped off the back and ran towards the house.

'Frankie!' Sinead cried as she walked out into the hallway to greet Marina.

Marina dashed up the front path, then stopped dead. 'Frankie!' she gasped.

Sinead backed into Travis. Rob caught up with Marina.

'Oh God!' Frankie croaked, turning this way and that. 'I'm sorry, I forgot. I'll go away again. Pretend I wasn't here!'

Rob was the first to break the formation. He dashed forward and hustled Frankie into the front room. Then he and Travis beat a hasty retreat into the kitchen.

'But you *are* here,' Sinead pointed out.

'Yeah, what do we do – press the Delete button?' Marina asked with a hollow laugh.

Frankie held her breath. 'Go ahead, throw me out,' she invited.

Marina glanced helplessly at Sinead, who looked pale and shocked. There was a long, gut-wrenching silence.

'And by the way, Wim is history,' Frankie told them, squeezing past Sinead as she made for the door. 'I finally came to my senses. He's so not my type.'

While Marina made a dive to stop Frankie from leaving, Sinead flopped onto the sofa. 'Oh, babe!' she groaned.

Frankie dodged Marina and sidestepped round the back of a floor cushion. 'It's OK, I'm cool about Wim, except for a few bits of broken heart left splattered on the pavement outside Escape.' She tried to grin in the old, Frankie way, but it was a feeble attempt. 'What really bugs me is the way I messed up with you guys.'

'Big time,' Marina agreed. 'But then, so did we.'

'Yeah, we're sorry,' Sinead sighed.

'*You're* sorry?'

'Totally!' Marina confirmed.

Frankie's eyes were as big as saucers. 'But I'm the one who's in the wrong!'

An electric tension crackled round the room. No one moved.

Then Travis and Rob burst back in. 'For Christ's sake, breathe, someone!' Travis begged.

Marina glanced at Sinead, who moved in on Frankie. 'Did you know you left your hair straighteners switched on in my room?' she challenged.

'Yeah, and your dead pasta's been clogging up the kitchen sink for four whole days!' Marina frowned.

The corners of Frankie's mouth quivered upwards. 'So am I out for good?'

'Your blue bra ruined my all-white wash!' Sinead went on with the list. 'Plus, there are strands of your hair in my brush.'

'And a hole in those patterned tights you borrowed from me,' Marina cut in, 'and my full bottle of John Frieda shampoo is mysteriously half empty . . .'

'OK, I'm out of here!' Frankie cried, her hands over her ears.

'And we want you to move back in!' Sinead and Marina yelled.

Frankie let her arms drop to her sides. 'You're mad!' she gasped.

'Totally crazy!' Rob laughed.

Travis went and sat Frankie down on the sofa. 'You're staying,' he informed her. 'Don't bother to argue.'

So Frankie cried instead. There were tears rolling down her cheeks, then sighs of relief.

'Hug?' Sinead offered.

Marina pulled Frankie onto her feet and the three girls embraced.

'Hug?' Marina said to Travis and Rob.

The boys backed away, their hands raised in self-defence. 'Way too girly,' Rob muttered.

'But go ahead, you three, it's cool,' Travis grinned.

Frankie, Sinead and Marina went into a triple bear hug that became a shuffle and then a sway that soon turned into a chorus . . .

'*Another year over, a new one just begun!*'

'*It's Christmas!*' Rob crowed.

'Cheese-tastic!' Frankie grinned.

'It's one o'clock. Is anybody tired?' Travis demanded.

'No.'

'No.'

'No.'

'No.'

'Call a cab!' Marina cried. 'We have to go out and celebrate.'

'Where to?' Rob asked as he rang for the taxi.

'Who cares?' Sinead laughed.

'Yeah!' Frankie agreed. 'Who cares? Let's party!'

# PRADA PRINCESSES
## by Jasmine Oliver

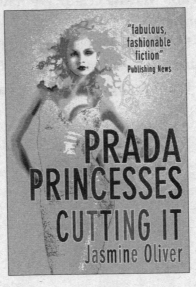

"fabulous, fashionable fiction"
Publishing News

The summer show looms at fashion college and the girls are under pressure.

Marina fights for more space for her funky shoe designs, while fledgling model, Frankie, wants to boycott the assessment and strut her stuff on the Paris catwalks instead. Sinead, meanwhile, ditches silks and satins in favour of daring body art. So it's all frayed nerves and fall outs as Travis films them 24/7 for his fly-on-the-wall documentary.

What else is new? Oh yes; Marina's family crisis. Will big, strong Rob keep her from falling apart? Will Sinead and Frankie still be there for her as the day of the final show draws near?

ISBN 1-416-90104-3